LIFE

LEGENDS

THE CENTURY'S
most unforgettable faces

LEGENDS
The Century's Most Unforgettable Faces

EDITOR: Killian Jordan
DIRECTOR OF PHOTOGRAPHY: Barbara Baker Burrows
ART DIRECTOR: Sharon Okamoto
PICTURE EDITOR: Patricia Cadley
ASSOCIATE PICTURE EDITOR: Maggie Berkvist
CONTRIBUTING WRITER: George Howe Colt
PHOTO RESEARCH ASSISTANT: Neal Jackson
REPORTER: Susan Feinberg
DESIGN ASSISTANT: Sarah Garcea
COPY DESK: Madeleine Edmondson, Larry Nesbitt
and all members of the LIFE Copy Department

Time Inc. Home Entertainment
MANAGING DIRECTOR: David Gitow
DIRECTOR, CONTINUITIES AND SINGLE SALES: David Arfine
DIRECTOR, CONTINUITIES AND RETENTION: Michael Barrett
ASSISTANT DIRECTOR, CONTINUITIES: John Sandklev
DIRECTOR OF NEW PRODUCTS: Alicia Longobardo
PRODUCT MANAGERS: Robert Fox, Michael Holahan, Amy Jacobsson, Jennifer McLyman
MANAGER, RETAIL AND NEW MARKETS: Tom Mifsud
ASSOCIATE PRODUCT MANAGERS: Alison Ehrmann, Dan Melore, Pamela Paul,
Charlotte Siddiqui, Allison Weiss, Dawn Weland
ASSISTANT PRODUCT MANAGERS: Alyse Daberko, Meredith Shelley, Betty Su
EDITORIAL OPERATIONS MANAGER: John Calvano
FULFILLMENT DIRECTOR: Michelle Gudema
FINANCIAL MANAGER: Tricia Griffin
ASSISTANT FINANCIAL MANAGER: Heather Lynds
MARKETING ASSISTANT: Lyndsay Jenks

Consumer Marketing Division
PRODUCTION DIRECTOR: John E.Tighe
BOOK PRODUCTION MANAGER: Donna Miano-Ferrara
ASSISTANT BOOK PRODUCTION MANAGER: Jessica McGrath

PICTURE SOURCES are listed by page. Cover: The Kobal Collection. 7: top, Eve Arnold/Magnum Photos; Yousuf Karsh/Woodfin Camp & Assoc. 8: top, James Abbe/MPTV; Bob WIlloughby/MPTV. 9: top, Linda McCartney; Harry Benson. 11: Courtesy The Franklin Mint. 33: Collection Marshall N. Levin. 101: Smithsonian Institution/ Eric Long, Photo #94-9418. 149: Courtesy Mattel Inc. Archives 174: © AFF/AFS, Amsterdam, The Netherlands. Back cover: top to bottom, John Mulholland, Norman Parkinson/Hamiltons Photographers Ltd.; Alfred Eisenstaedt

Copyright 1997
Time Inc. Home Entertainment

Published by

Books
Time Inc.
1271 Avenue of the Americas
New York, New York 10020

Book edition distributed by Bulfinch Press,
an imprint and trademark of
Little, Brown and Company Inc.
Boston, New York, Toronto, London

First Edition
ISBN 0-8212-2504-9
Library of Congress Catalog Card Number 97-61119
"LIFE" is a registered trademark of Time Inc.

PRINTED IN THE UNITED STATES OF AMERICA

LIFE

LEGENDS

THE
CENTURY'S
most
unforgettable
faces

LEGENDS

INTRODUCTION BY
GEORGE HOWE COLT

W

HEN ASKED

to account for Greta Garbo's spellbinding magnetism, Pulitzer Prize–winning playwright Robert Sherwood burbled like a high school fan club president. "She is one of the most amazing, puzzling, most provocative characters of this extraordinary age," he said. "She definitely doesn't belong in the 20th century. She doesn't even belong in this world."

Sherwood's imprecision illustrates a certain truth about those exalted personages we call legends: They are hard to define, but we know one when we see one. They shimmer in the firmament of renown, out there beyond celebrity, beyond fame. According to *The Oxford English Dictionary,* the first definition of the word *legend* is the story of the life of a saint. Although some of the legends on the following pages are far from saintly—indeed, a few stake their claim to fame on the basis of decidedly unholy acts—they all possess, if not a halo, a certain ineffable aura.

Legends transcend. They loom, Rushmore-size, in our imaginations. They serve as forms of measurement: An outsize deed is dubbed Ruthian, a notable recluse becomes Gar-

they share one thing: the ability to mesmerize mere mortals.

Yet they are not mere mortals themselves. Like the great historical legends (think Marco Polo or Genghis Khan), today's legends are people around whom tall tales proliferate. When we can't tell the difference between fact and fancy, we know a legend is in the making. Did Babe Ruth really point to the bleachers in Wrigley Field before smiting his famous "called shot"? Did Elvis and his entourage really fly a thousand miles for peanut butter and jelly sandwiches? Don't ask; they're legends. And legends, like

MALCOLM X

"If I'm such a legend, then why am I so lonely?"
—JUDY GARLAND

boesque. And yet we feel on intimate terms with them. In the late 1960s, a furrier's advertising campaign featured photographs of certain famous people beneath the words "What becomes a Legend most?" Names weren't mentioned; they weren't needed for the likes of Marlene Dietrich, Judy Garland and Maria Callas. After some years, the company was forced to dip into the ranks of mere celebrity—Dinah Shore, Jessica Tandy, Tommy Tune. The difference, however difficult to articulate, was nonetheless obvious.

In this book, we have collected memorable, and in many cases seldom-seen, photographs of people who need no introduction. To provide insight into these remarkable people, we've quoted from others who are legends or near-legends in their own right. (In some cases we've edited their observations for clarity.) While no two of the giants in this volume are alike, they share one thing: the ability to

any form of fiction, require a willing suspension of disbelief. After the death of the Great Lover—Valentino—more than a few women claimed him as the father of their children, yet several biographers have suggested that he was impotent.

What lifts someone into legend? It can't be just achievement. Arnold Palmer is a legend but not Jack Nicklaus, who was undeniably the better golfer. John Barrymore is, but not Lionel or Ethel, who were, critics agree, at least his equals as actors. "What makes someone legendary as opposed to a mere celebrity is that there's a particular tale that goes with the name—a fable, a myth," says Richard Slotkin, a professor of American Studies at Wesleyan Uni-

ELEANOR ROOSEVELT

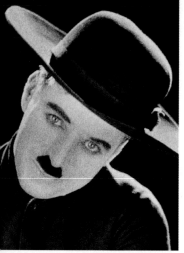

CHARLIE CHAPLIN

versity, who has written extensively about myth in popular culture. "Their life makes a story. And when you say that name, everyone knows the story implied by that name." Instead of *The Steadfast Tin Soldier* we have The Great Baseball Player Who Married a Movie Star and Was Loyal unto Death. Instead of *The Ugly Duckling,* we have The Foster Child Who Became a Legendary Beauty but Never Found Happiness and Died of a Drug Overdose.

Legends also have a knack for being in the right place at the right time. It is no accident that Harry Houdini rose to leg-

ture of her, she was a genius." Power—on a grand scale—is an acceptable substitute for beauty. And tragedy is an undeniable stimulant to legend. A memorable nickname can also help. On the following pages we find Satchmo, Lady Day, the Little Sparrow, the Bambino, John-John, the Yankee Clipper, the Platinum Blonde, Duke, Papa.

Although it may be impossible to create a legend out of whole cloth, a flair for promotion helps, so Hollywood begets a disproportionate number of legends. After all, legends are a bit like movies themselves: a huge screen on which we project our hopes, fears and desires. Indeed, the use of the word *legend* to describe a person, not a story, wasn't common until Hollywood made it popular. By the '30s, studios were chang-

"Legends die

end around the turn of the century, when immigrants were flooding America's shores seeking their own sort of escape. And when America was flexing its muscles as a new world power, Hemingway came along to serve as a poster boy for chest-thumping, testosterone-charged he-man-hood.

We can identify some other ingredients that turn up fre-

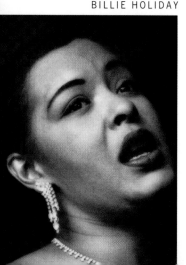

BILLIE HOLIDAY

quently. A whiff of great romance is almost essential, and if it involves another legend (Bogart and Bacall, Hepburn and Tracy), it adds exponentially to the legend's heft. Beauty certainly helps. As Billy Wilder once observed of Marilyn Monroe, "The first day a photographer took a pic-

ing actors' names, inventing outsize lifestyles for them and feeding the media with romantic tall tales. One of their greatest creations was John Wayne. He hated horses yet became the embodiment of America's frontier spirit. He maneuvered mightily to avoid serving in World War II, but Gen. Douglas MacArthur called him a better representative of the military "than the American Serviceman himself."

If legends can be created by pushing oneself on the world, they can also be created by withdrawing from it. Howard Hughes became famous for building an airplane and making movies, but not until he became a full-blown eccentric was he elevated to legend status. This admixture of outlandishness provides the frosting on the cake. Not only did the prodigy Glenn Gould master Book I of Bach's *Well-Tempered Clavier* at

age 10, but he wore gloves, hat, scarf and overcoat in summer. He once sang Mahler to the elephants at the Toronto Zoo at dawn. In concert, he hummed, groaned and sang along as he played, hunched over the keyboard like a jeweler examining a diamond. Then, at the age of only 31, he withdrew from the social world and never again played in public. Without his genius, Gould would be just another eccentric; without his eccentricity, he wouldn't be a legend.

Few things, of course, fix a legend more firmly in our memory than an early death—especially when it abbreviates a full-throttle life. The life ends, the legend begins. Amelia Earhart isn't lodged in our collective memory for her substantial achievements as a pilot but for running out of gas over the

hard.
They survive as truth rarely does."
—HELEN HAYES

Pacific and disappearing forever. John F. Kennedy, James Dean, Jim Morrison, Jimi Hendrix, Kurt Cobain—their legends were all enhanced by the perfume of early death. One suspects that if Janis Joplin had lived a long life and died in her sleep, she'd be no more a legend than Stevie Nicks.

But even before death, the legend can consume the life. One thinks of Kerouac in middle age, with young hippies knocking at his door, expecting to meet the beatific, exuberant hipster of *On the Road* but finding a bloated, paranoid, arch-conservative drunk, tethered irrevocably to his suffocating mother. Orson Welles, Judy Garland, Ernest Hemingway,

Michael Jackson: The names conjure up people who are locked in competition with their own legends, compelled to live up to them.

No matter how great their destructive potential, we need legends. So we create them. They are fundamental to human identity. And

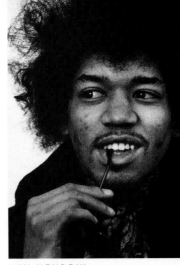
JIMI HENDRIX

just as Masai legends, for example, tell the tribe about their world, so the legends on the following pages tell us about 20th century America, about our dreams, preoccupations and yearnings. As we remember Joan of Arc, Socrates and Cleopatra, it is possible that people centuries from now will remember the faces on the following pages—Sigmund Freud, Mae West, Albert Einstein . . .

Near the end of his life, John Barrymore appeared on Broadway one last time. It had been three decades since he'd first brandished his celebrated profile onstage. In *My Dear Children* he essentially played himself: an aging, inebriated, womanizing matinee idol. Interviewed backstage by a newsreel crew, Barrymore appeared drunk, slurring his words and hamming for the cameras—a pitiable husk of the actor whose brilliant Hamlet had set the modern standard. And then Barrymore said, "They wish to see the Barrymore profile. That is, as much of it that is left. Here goes." He paused and then, with the startling quickness of a hawk, turned his head—to reveal

his left profile, which he considered his best. There, buried beneath the dewlaps and double chin, but still visible, like a diamond in slag, was the legendary Barrymore profile. Like all legends, it had a life of its own, and nothing in heaven or earth could destroy it. ☐

BOBBY FISCHER

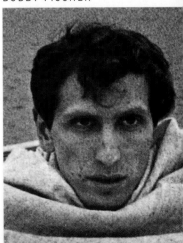

"I'm against a homogenized society because I want the cream to rise."

—ROBERT FROST

JACQUELINE KENNEDY ONASSIS' NECKLACE

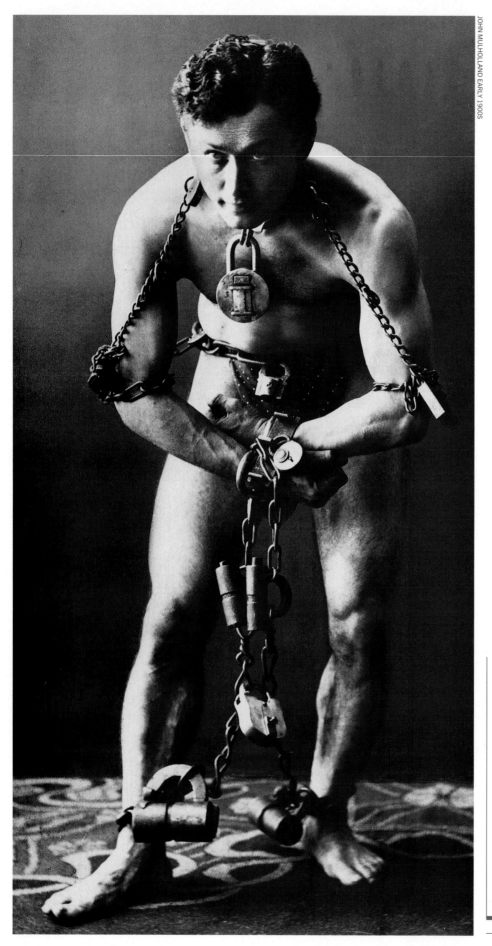

▶ **TRUMAN CAPOTE 1924–1984**

"At first you can't believe him, he's so odd, and then you want to carry him around with you always."

—HUMPHREY BOGART

◀ **HARRY HOUDINI 1874–1926**

"His message was that every obstacle could be overcome. The escapes were a metaphor that gave people hope at a time when it was most needed."

—DAVID COPPERFIELD

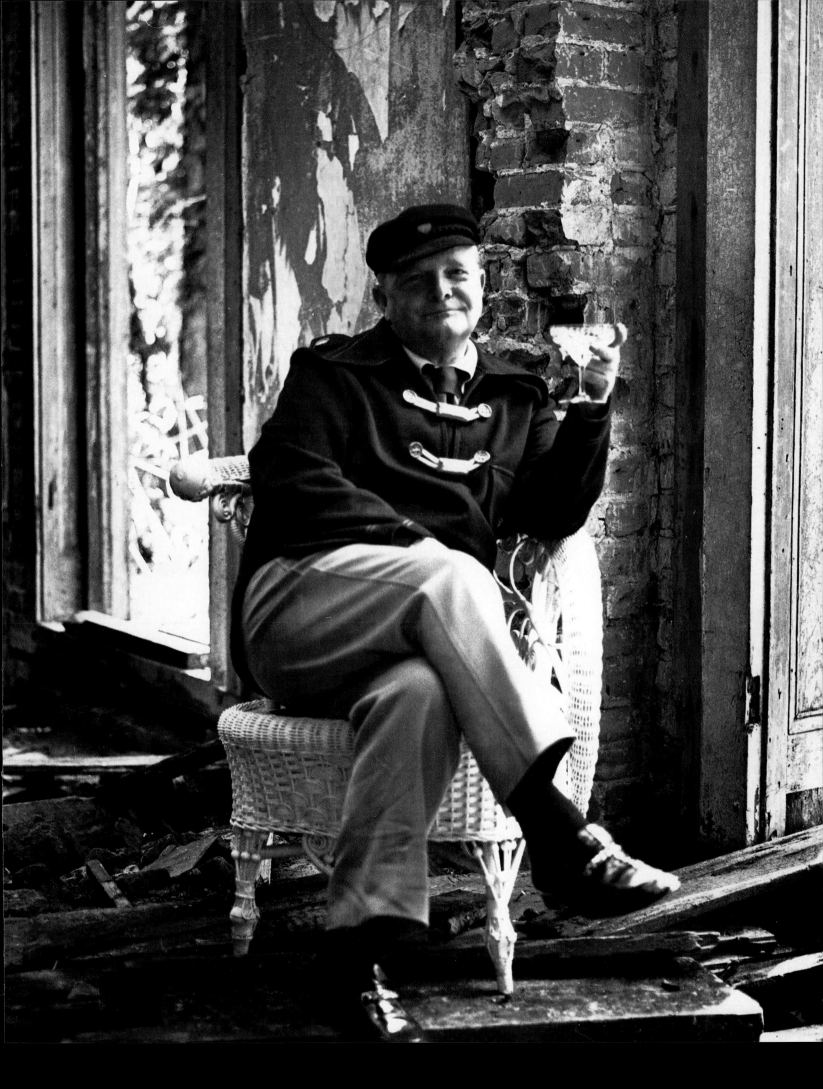

"Don't be afraid to kiss your baby when you feel like it."

—DR. BENJAMIN SPOCK

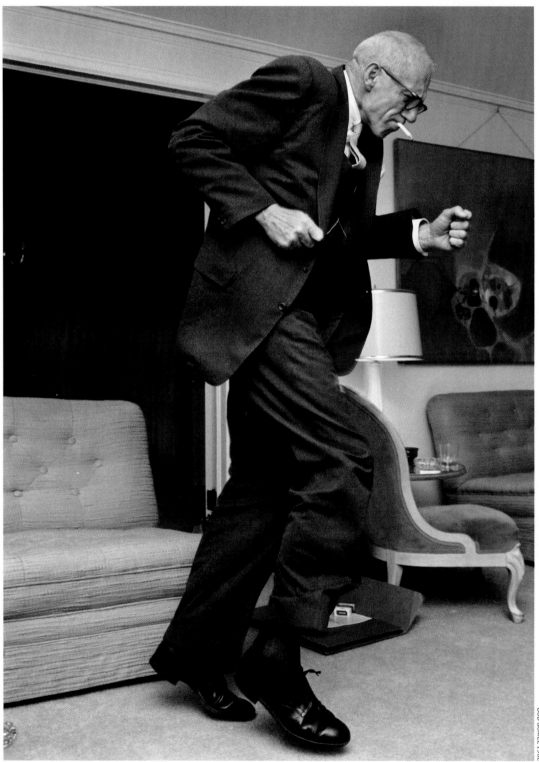

BURT GLINN/MAGNUM PHOTOS 1959

BOB GOMEL 1962

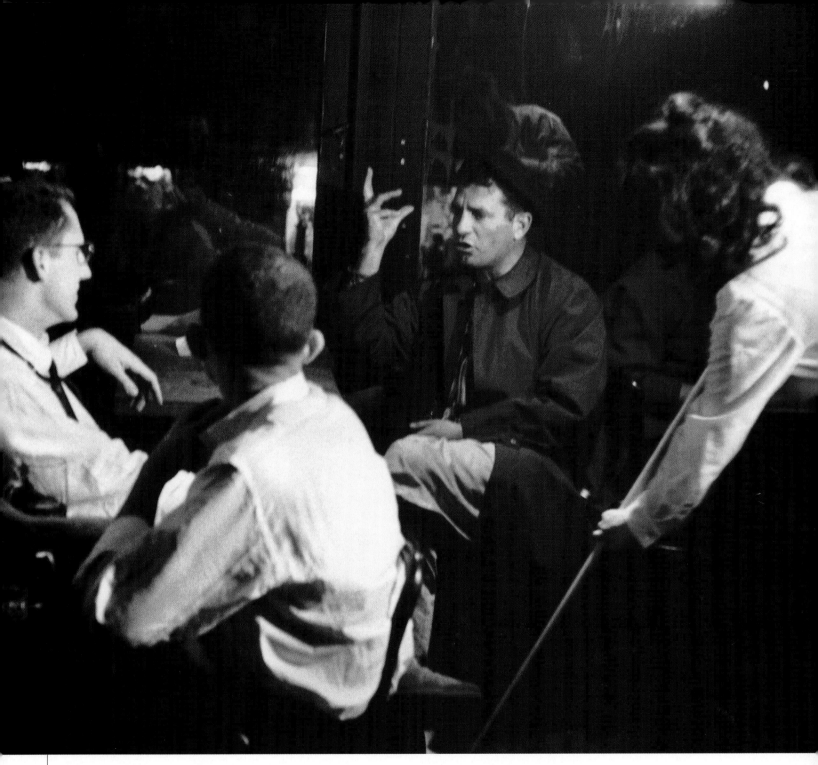

▲ JACK KEROUAC 1922–1969

"Next I noticed the continual current of gentleness running beneath that raw spiel of rough words, the mercy with which he described the vast and varied flock summoned from his memory—the tootsies and floozies, fags and wimps and dope fiends, killers and convicts and bullying sailors, hustlers and losers and phonies of the first water— yet, in all his long considering, he never puts a soul of them down."

—KEN KESEY

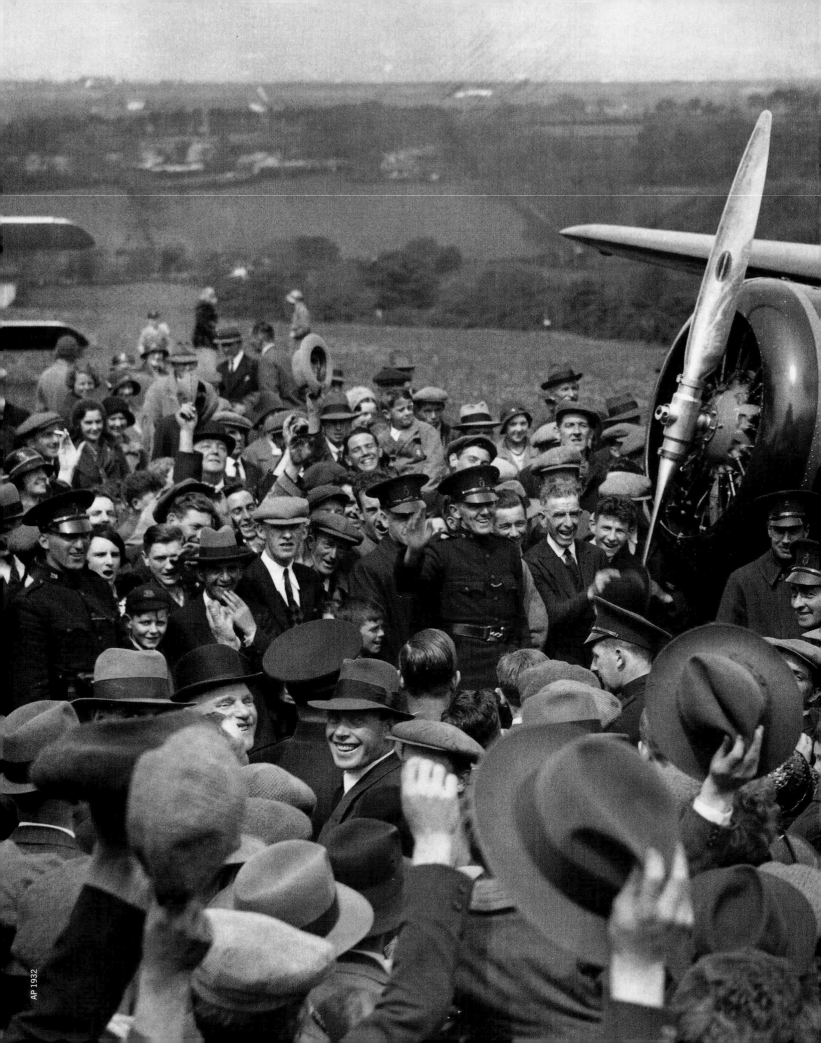

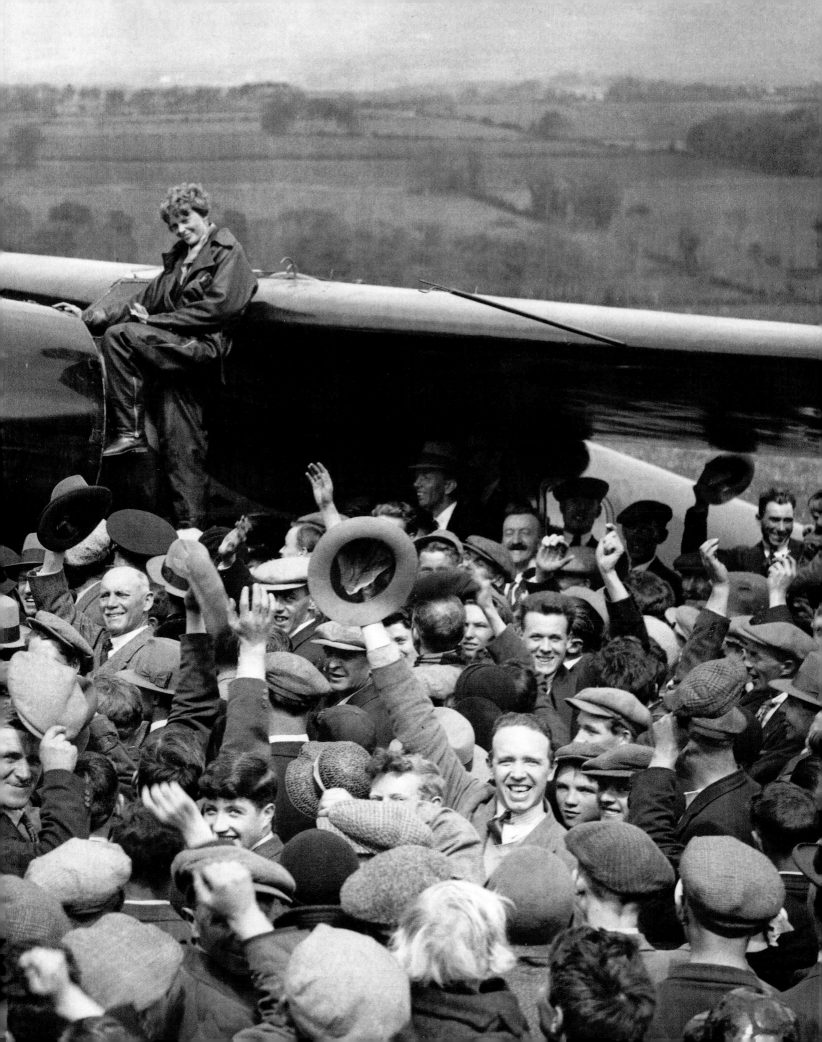

"Well, when they got back, they summoned us for a reading of our script [for *Monkey Business*]. They came with their lawyers and accountants and masseurs and dentists—23 people, plus Zeppo's two Afghans and Chico's schnauzer—and I read for 85 minutes in absolute silence. At the end Chico said, 'Whaddya think, Grouch?' Groucho took the cigar out of his mouth and said 'Stinks!' and they all got up and walked out."

—S.J. PERELMAN

► SIGMUND FREUD 1856–1939

"I was going to kill myself but . . . I was in a strict Freudian analysis and if you kill yourself, they make you pay for the sessions you miss."

—WOODY ALLEN

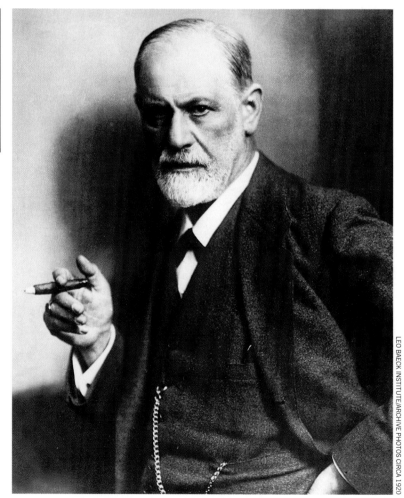

◄ AMELIA EARHART 1897–1937

"She just came at a time when it was popular for women to fly airplanes and she had the money to do it. Being an airplane driver myself, I'm not impressed."

—CHUCK YEAGER

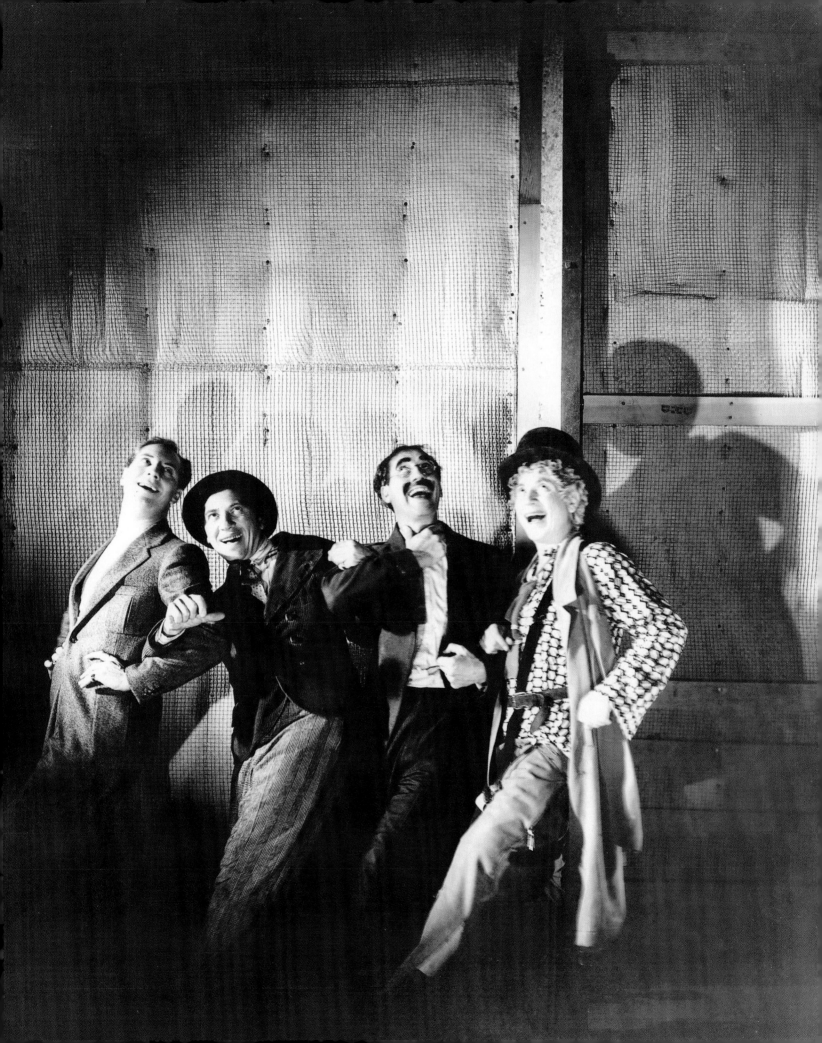

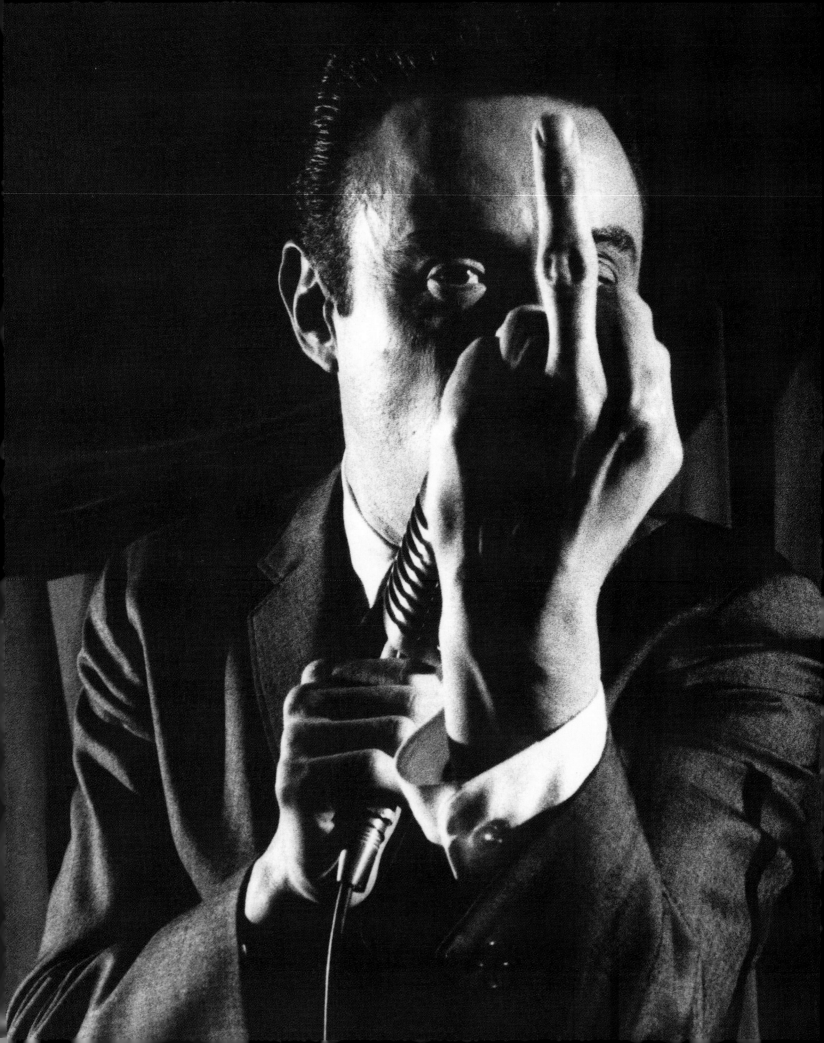

"What's remembered is his

dirty mouth.

What's forgotten is his purely

American innocence.

He believed that his act, his honesty, could open doors. And it did for the generation of comics, satirists, writers and artists that followed him. At his New York obscenity trial Lenny was found guilty, inspiring the rest of us to be free."

—JULES FEIFFER

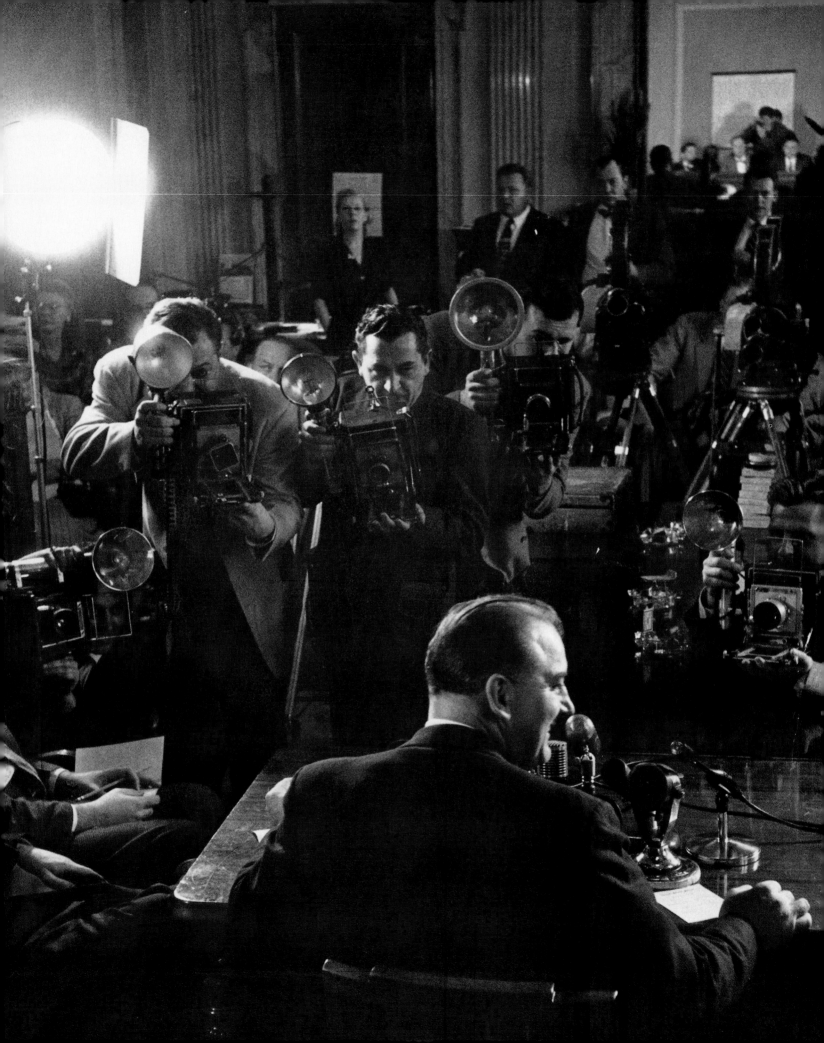

"McCarthyism…
It is the use of
the big lie
and the unfounded
accusation."

—HARRY S TRUMAN

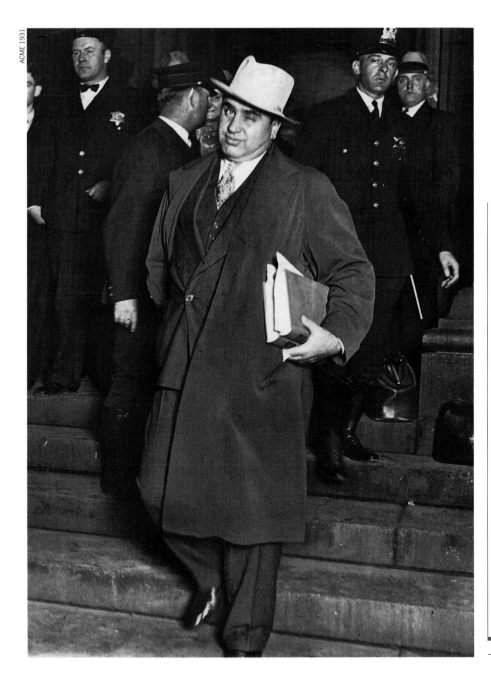

ACME 1931

HANK WALKER 1954

◄ AL CAPONE 1899–1947

"You can hardly be surprised at the boys killing each other. The business pays very well, but it is outside the law and they can't go to court, like shoe dealers or real-estate men or grocers, when they think an injustice has been done them, or unfair competition has arisen in their territory. So they naturally shoot."

—CLARENCE DARROW

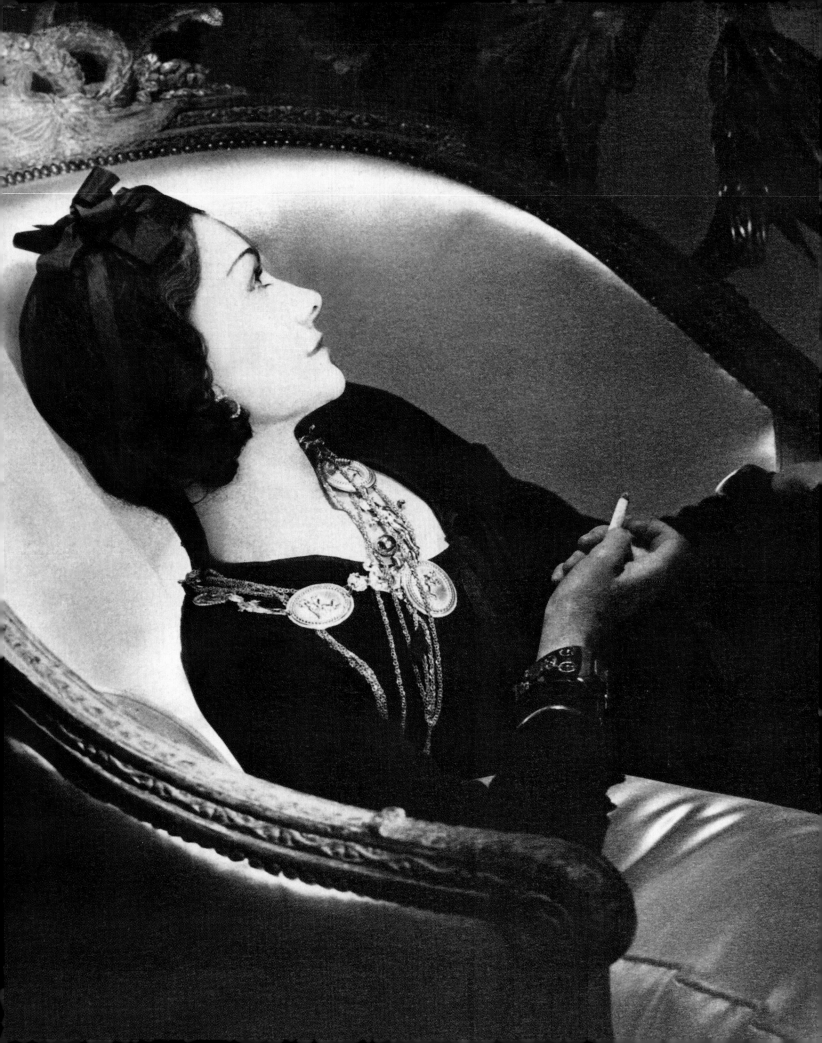

◀ COCO CHANEL **1883–1971**

"The *alertness* of the woman!

The charm!

She was mesmerizing, strange, alarming, witty."

—DIANA VREELAND

"He had true pitch.
Here was someone who in another age might have been a mystic."

—DR. JONAS SALK

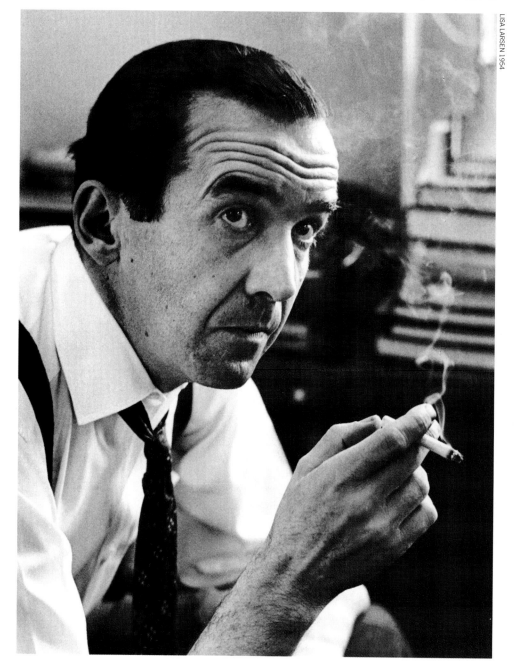

LISA LARSEN 1954

HY PESKIN 1949

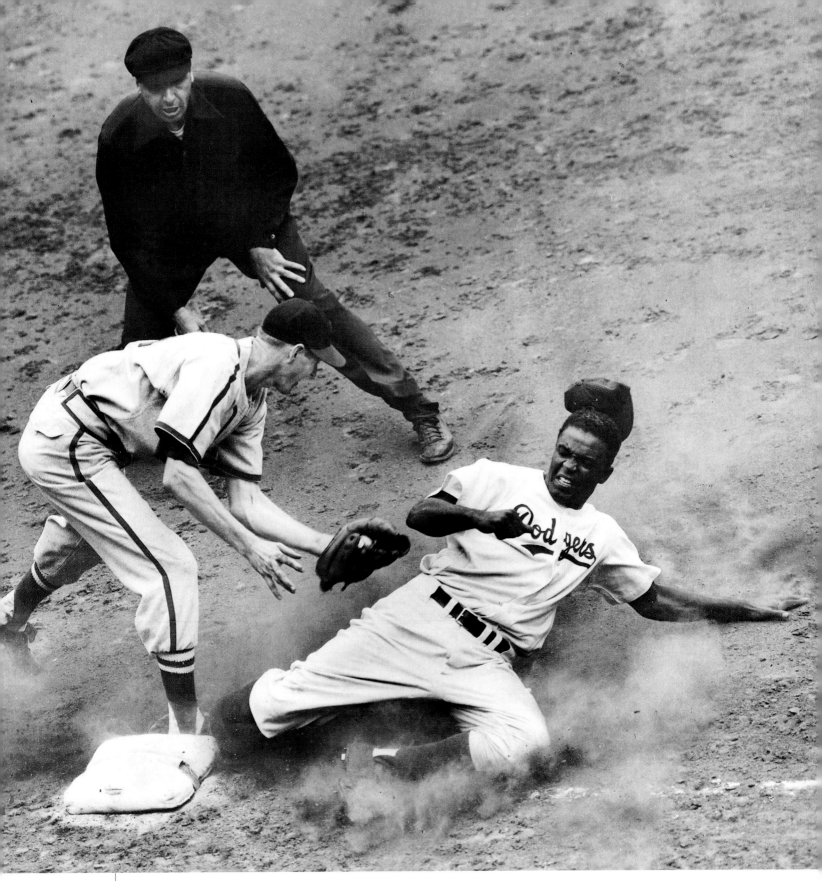

▲ JACKIE ROBINSON 1919–1972

"A Mrs. Roosevelt in spikes."

—WILFRID SHEED

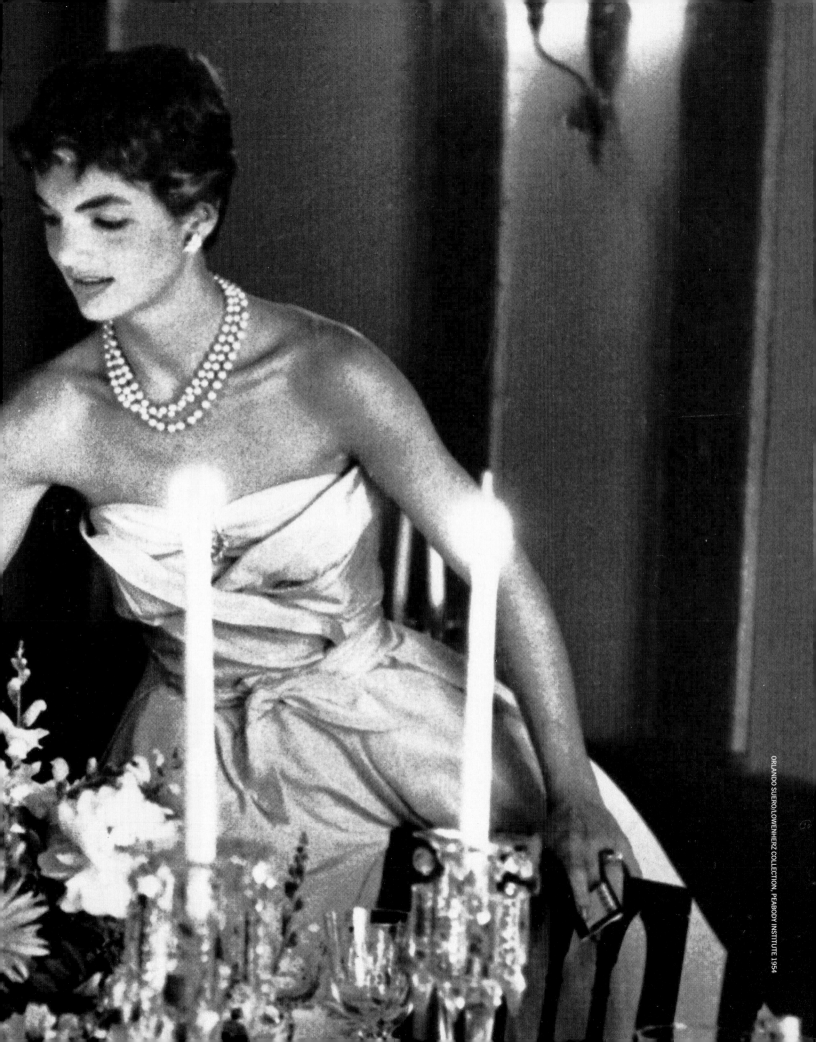

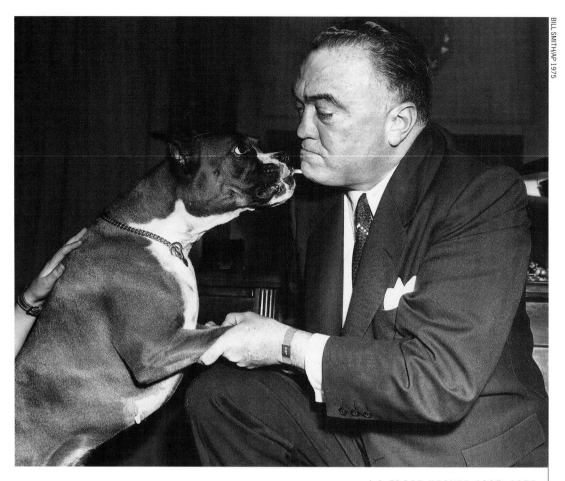
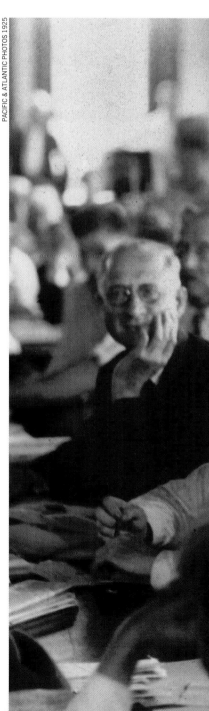

▲ J. EDGAR HOOVER **1895–1972**

"Dear Edgar,
Walter Winchell mention[ed] your name as a candidate
for President. If that should come to pass . . .
I would guarantee you the largest contribution that
you would ever get from anybody . . . I think the
United States deserves you. I only hope it gets you.
Sincerely, Joe"

—JOSEPH P. KENNEDY

◄ JACQUELINE KENNEDY ONASSIS **1929-1994**

"She was ours. She did not belong to herself.
She was twice ours, once as the most beautiful
and romantic legend we had ever had in a
First Lady; afterward she was ours as the
first monumental American widow."

—NORMAN MAILER

"The set [for *Inherit the Wind*] wasn't quite ready.
I couldn't figure out why, so I went around to see the
carpenters who were supposed to be building it.
I found them deep in dispute as to
whether man could
have descended from apes."

—STANLEY KRAMER

"Nothing happens unless first a dream."

—CARL SANDBURG

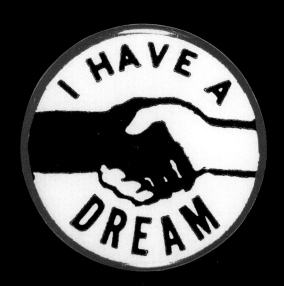

CIVIL RIGHTS BUTTON, CIRCA 1968

▶ **DR. MARTIN LUTHER KING JR.**
1929–1968

"I have the
feeling that
the Lord
has laid his
hands on you,
and that is a dangerous,
dangerous thing."

—BAYARD RUSTIN

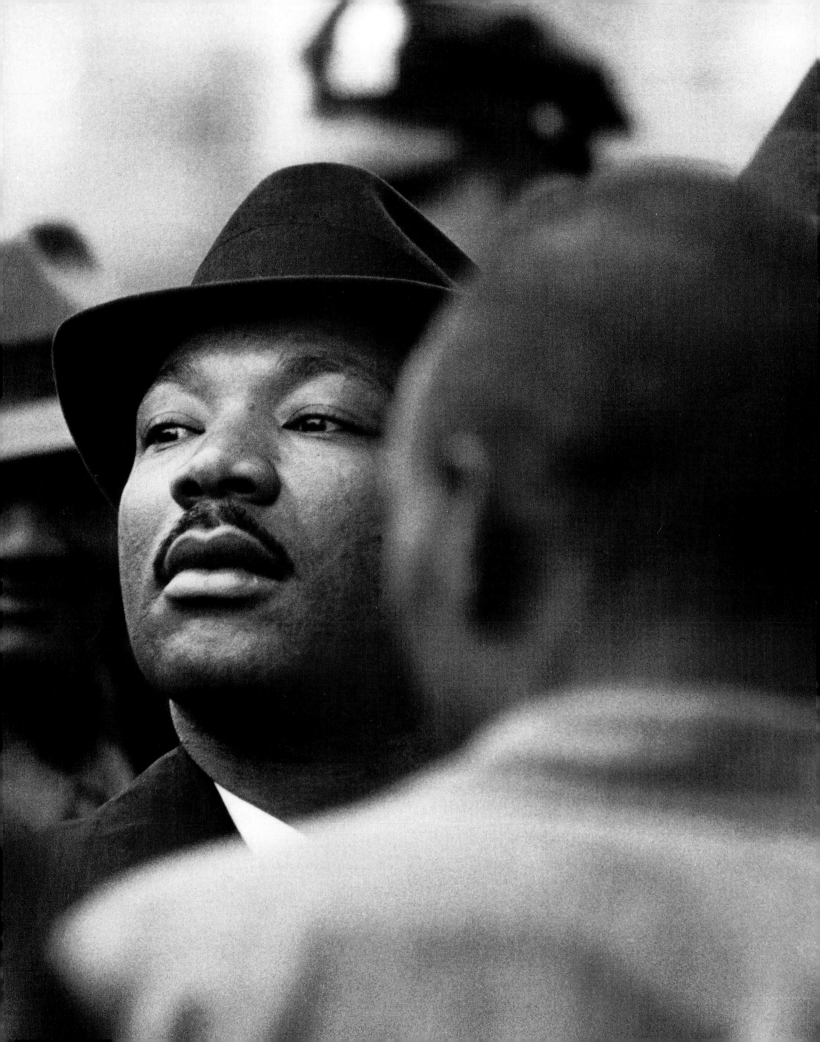

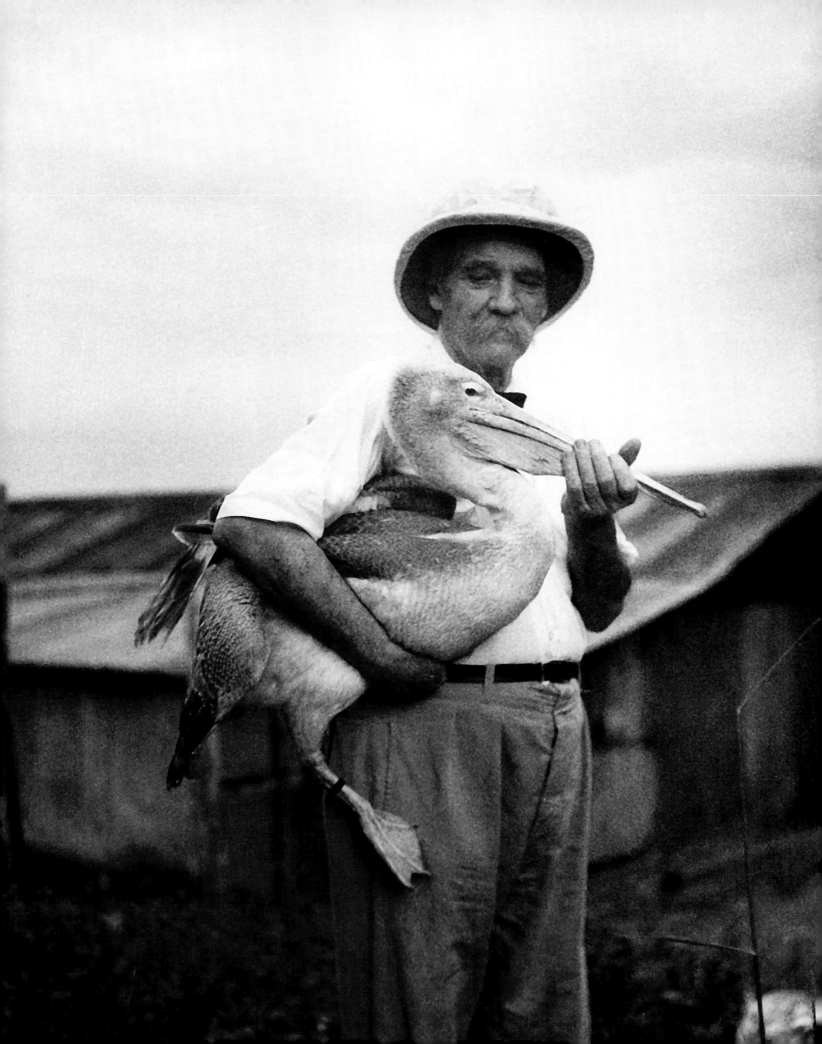

"He did not preach and did not warn and did not dream that **his example** would be an ideal and a comfort to innumerable people."

—ALBERT EINSTEIN

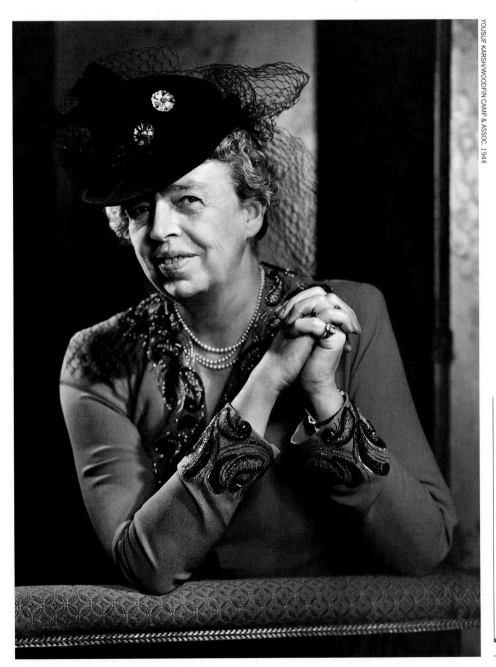

YOUSUF KARSH/WOODFIN CAMP & ASSOC. 1944

PIX INC. CIRCA 1960

"All of white South Africa . . . looked at him for the first time. And they saw a gentle man, a beautiful man, a man prepared to forgive."

—ATHOL FUGARD

"No woman has ever so comforted the distressed or so distressed the comfortable."

—CLARE BOOTHE LUCE

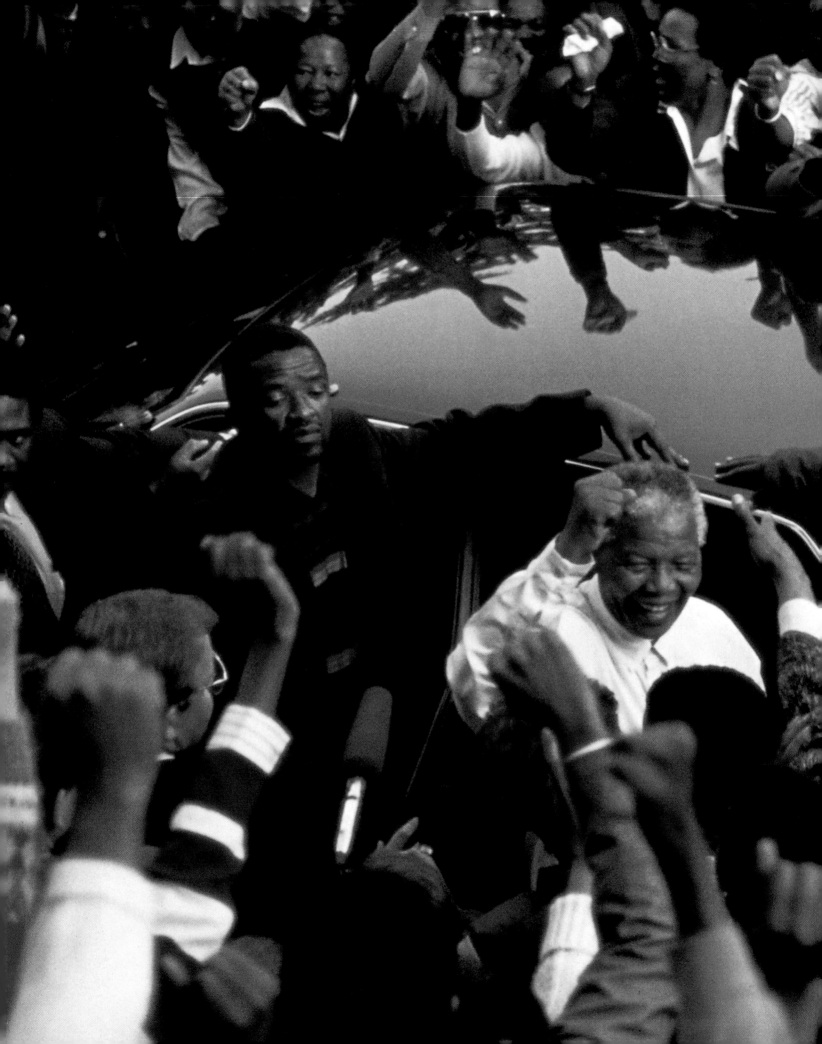

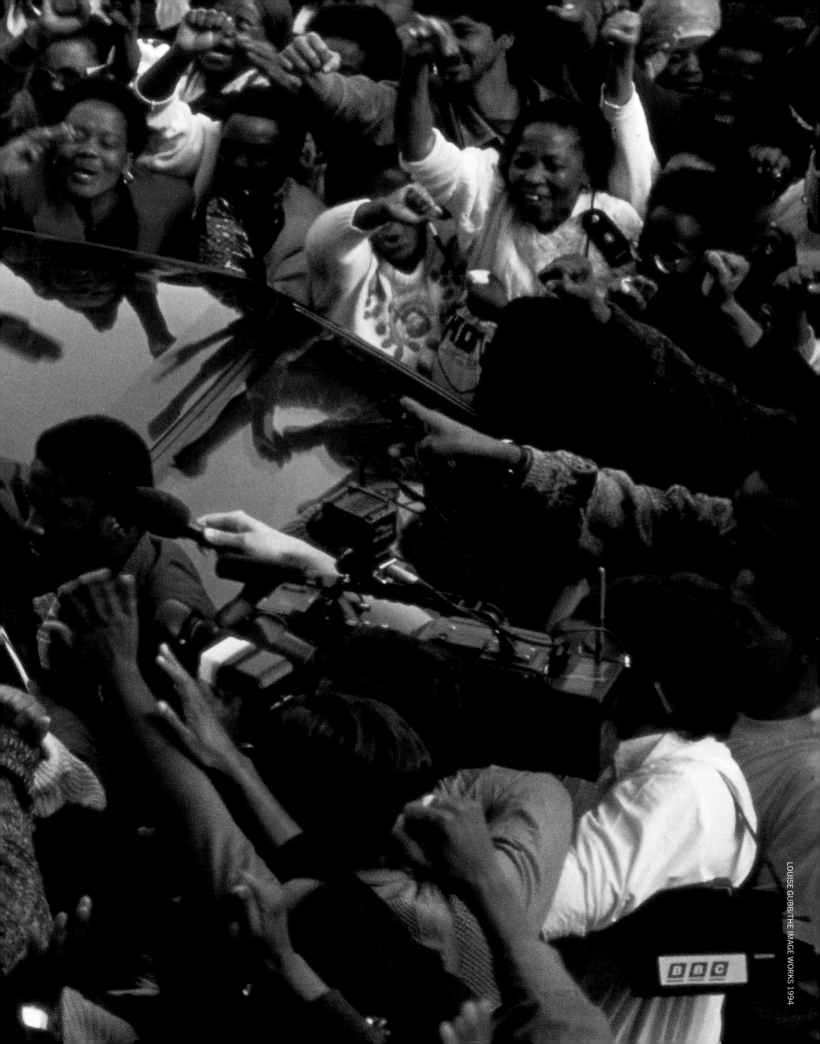

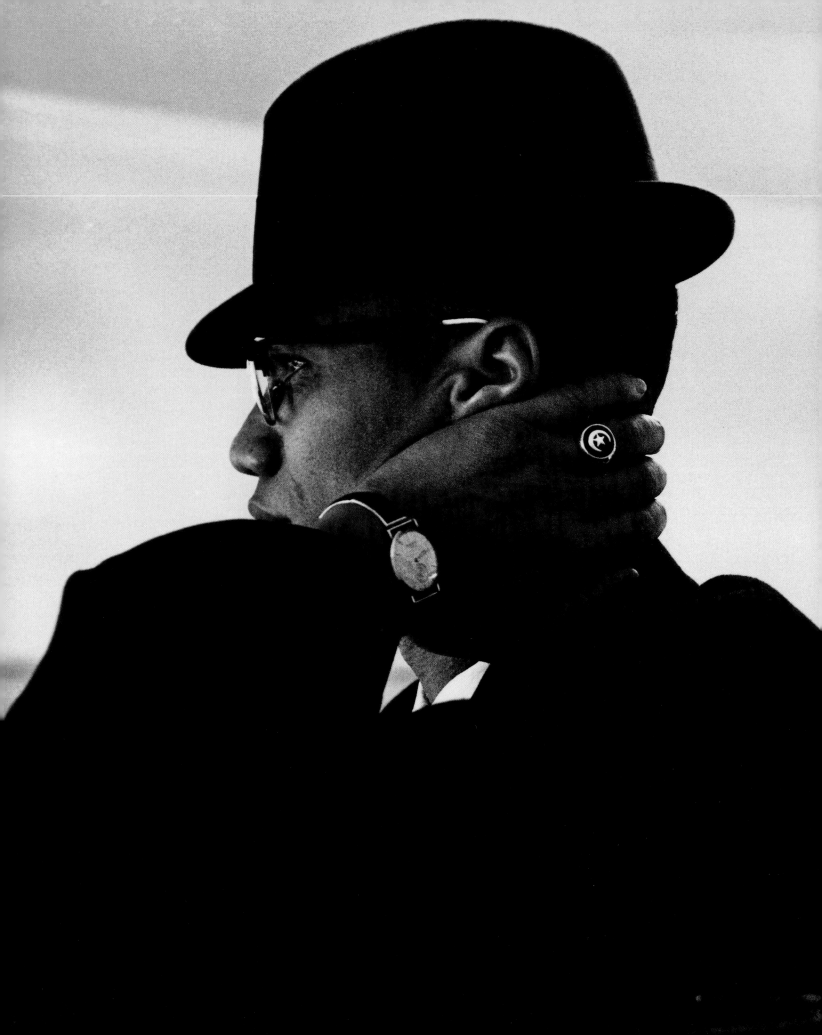

"I can't deny it.
When he starts talking about
all that's been done to us,
I get a twinge of hate…"

—DR. MARTIN LUTHER KING JR.

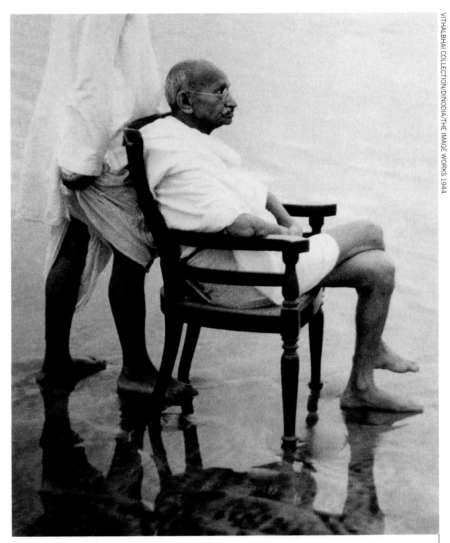

VITHALBHAI COLLECTION/DINODIA/THE IMAGE WORKS 1944

▲ MOHANDAS GANDHI 1869–1948

"We will not resort to violence, we will not degrade ourselves with hatred. We will return good for evil, we will love our enemies . . . Christ showed us the way and Gandhi in India showed it could work."

—DR. MARTIN LUTHER KING JR.

EVE ARNOLD/MAGNUM PHOTOS 1961

"Every man is a quotation from all his ancestors."

—RALPH WALDO EMERSON

GENERATIONS

MADONNA'S BUSTIER

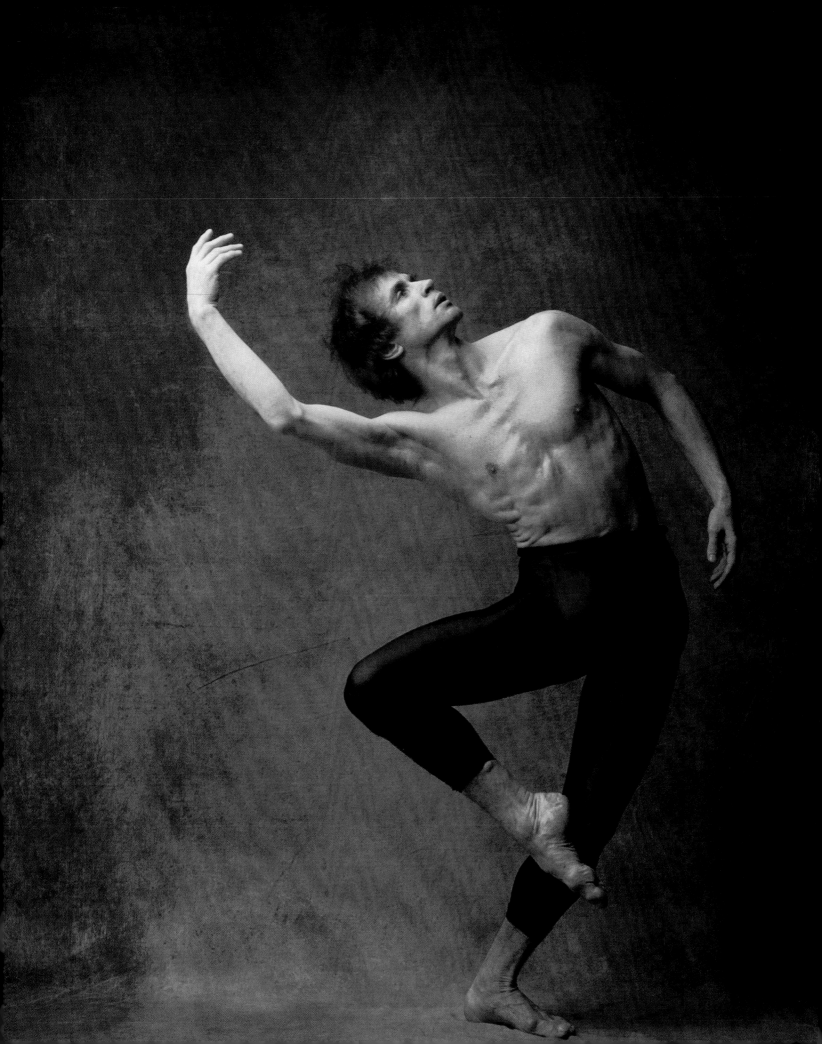

"An extremely, *extremely* attractive young man."

—MARIA TALLCHIEF

▶ **VASLAV NIJINSKY**
1890–1950

"He possesses
the beauty of
the antique
frescoes
and statues;
he is the
ideal model
for whom
every painter
and sculptor
has longed."

—AUGUSTE RODIN

"He kept sex, sadism, patriotism, real estate, religion and public relations dancing in midair like jugglers' balls for fifty years."

—AGNES DE MILLE

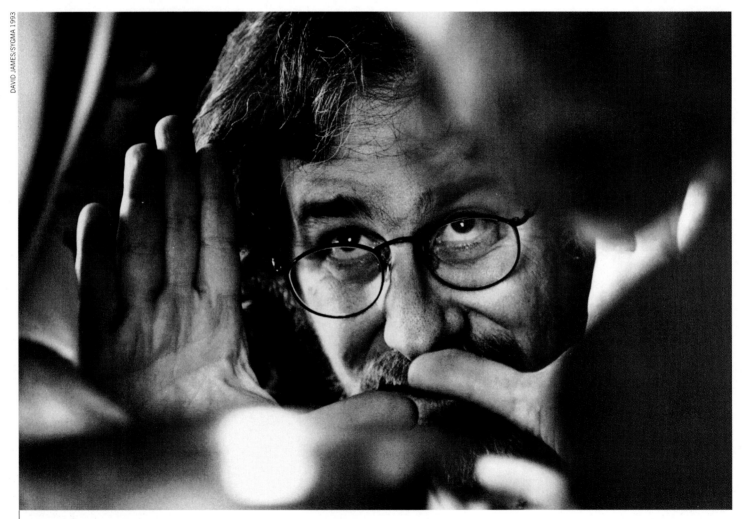

DAVID JAMES/SYGMA 1993

▲ **STEVEN SPIELBERG** 1947–

"People have forgotten how to tell a story."

—STEVEN SPIELBERG

46

RALPH CRANE 1954

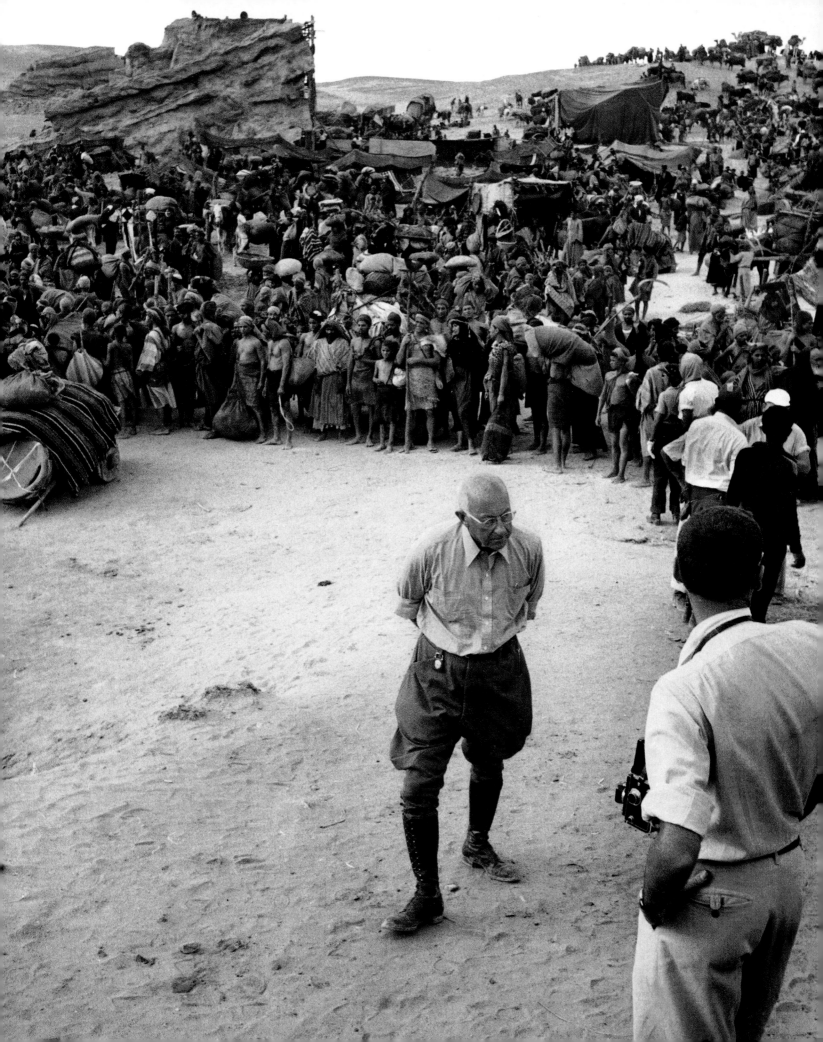

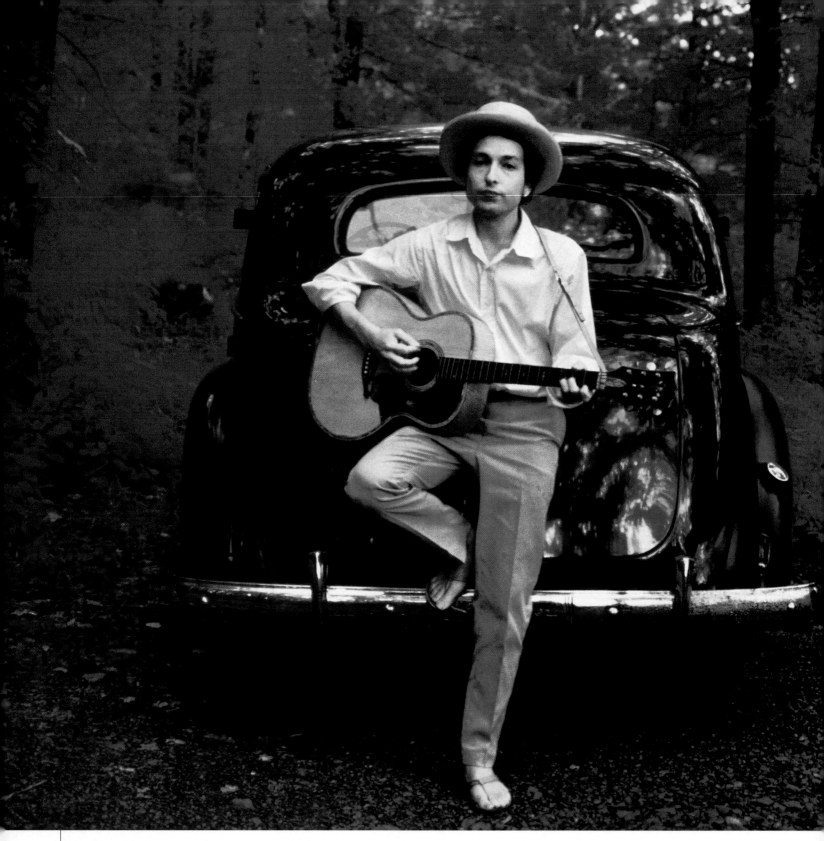

▲ BOB DYLAN 1941–

"You certainly look like an intense young man . . ."

—CARL SANDBURG

▼ **WOODY GUTHRIE 1912–1967**

"One paper down in Kentucky said what us Okies needed next to three good square meals a day was some good music lessons."

—WOODY GUTHRIE

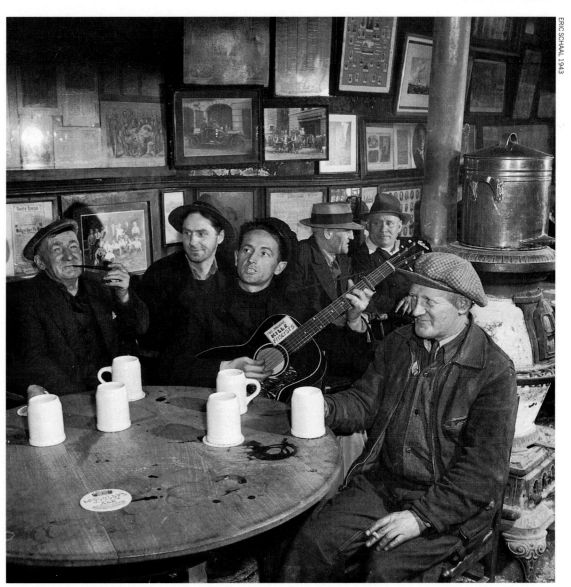

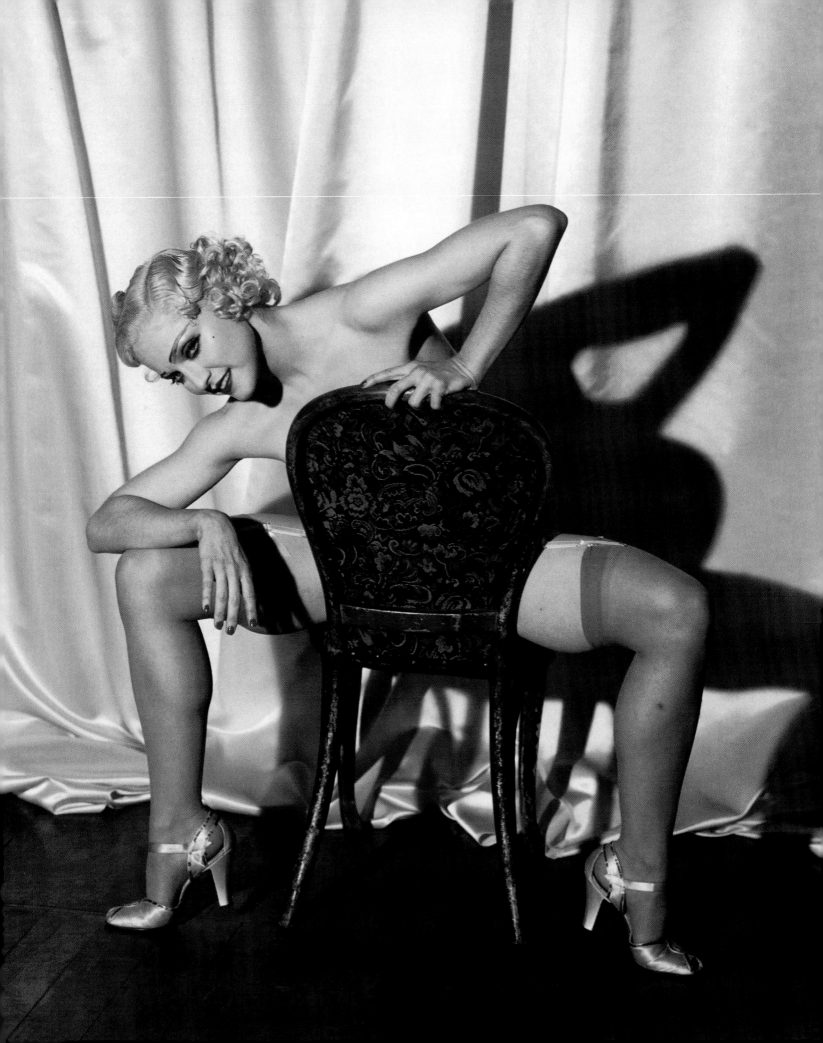

"She seems to love men;
she has made some men happy,
and they have made her happy.
Madonna has done a little living."

—HELEN GURLEY BROWN

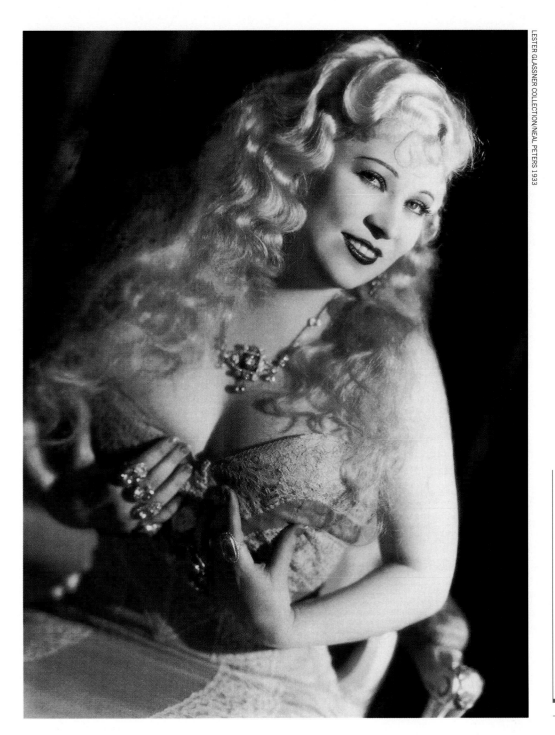

LESTER GLASSNER COLLECTION/NEAL PETERS 1933

STEVEN MEISEL/A&C ANTHOLOGY 1991

◄ MAE WEST 1892–1980

"Scimitar eyes with
sword-length lashes;
the white skin, white
as a cottonmouth's
mouth; the shape,
that Big Ben of
hourglass figures."

—TRUMAN CAPOTE

"This boy is not our usual type of hero.
He is all the others rolled into
one and multiplied by ten . . ."

—WILL ROGERS

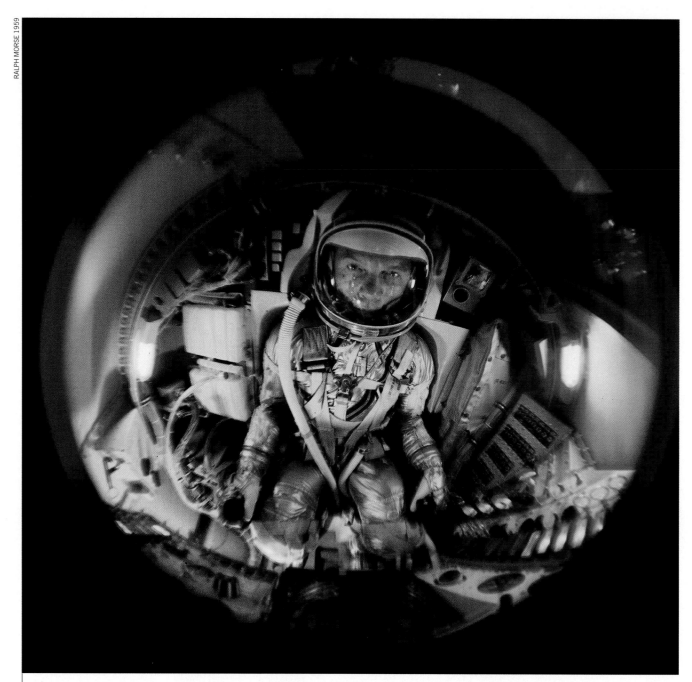

▲ JOHN GLENN **1921–**

"This guy had the halo turned on at all times!"

—TOM WOLFE

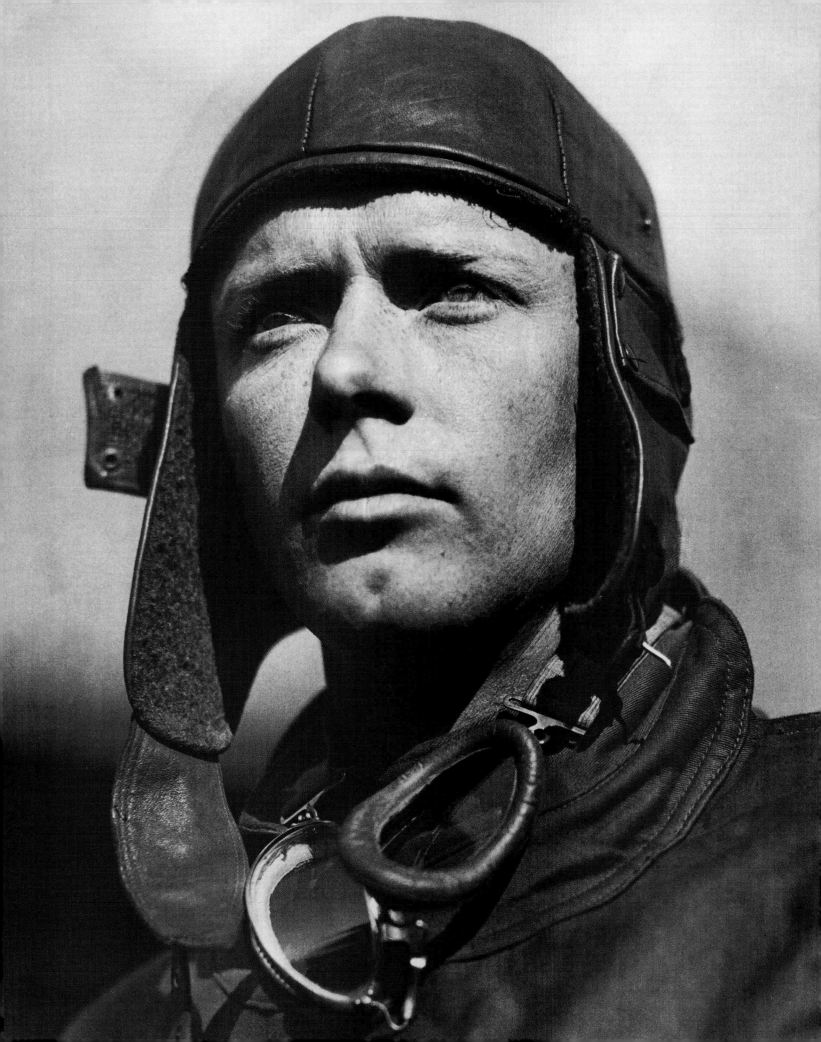

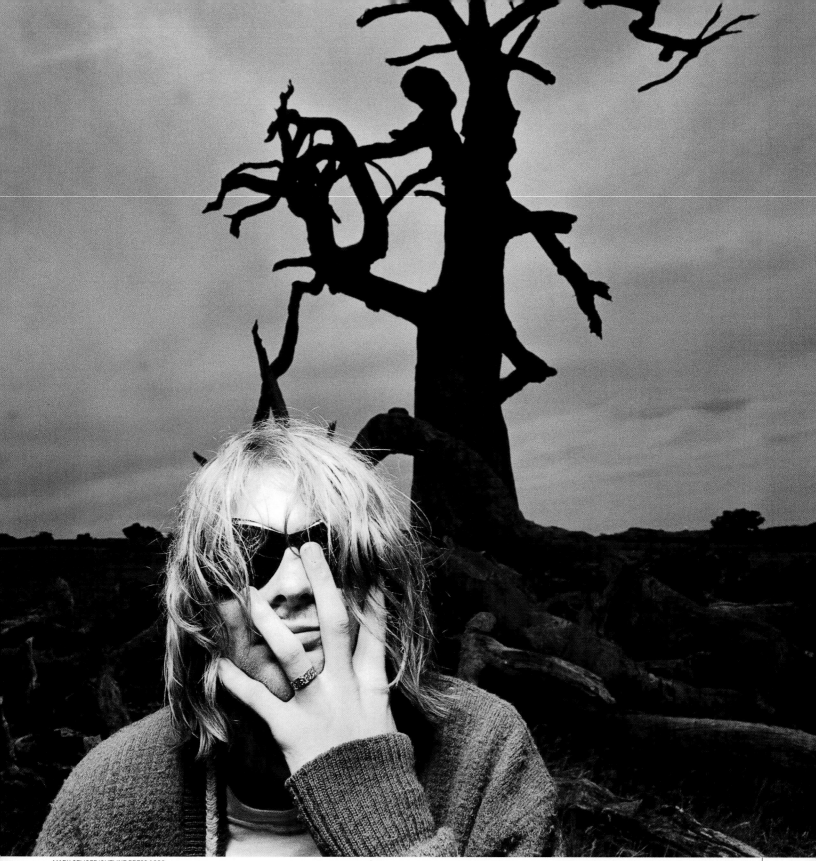

▲ KURT COBAIN 1967–1994

"There's something wrong with that boy.
He frowns for no good reason."

—WILLIAM BURROUGHS

54

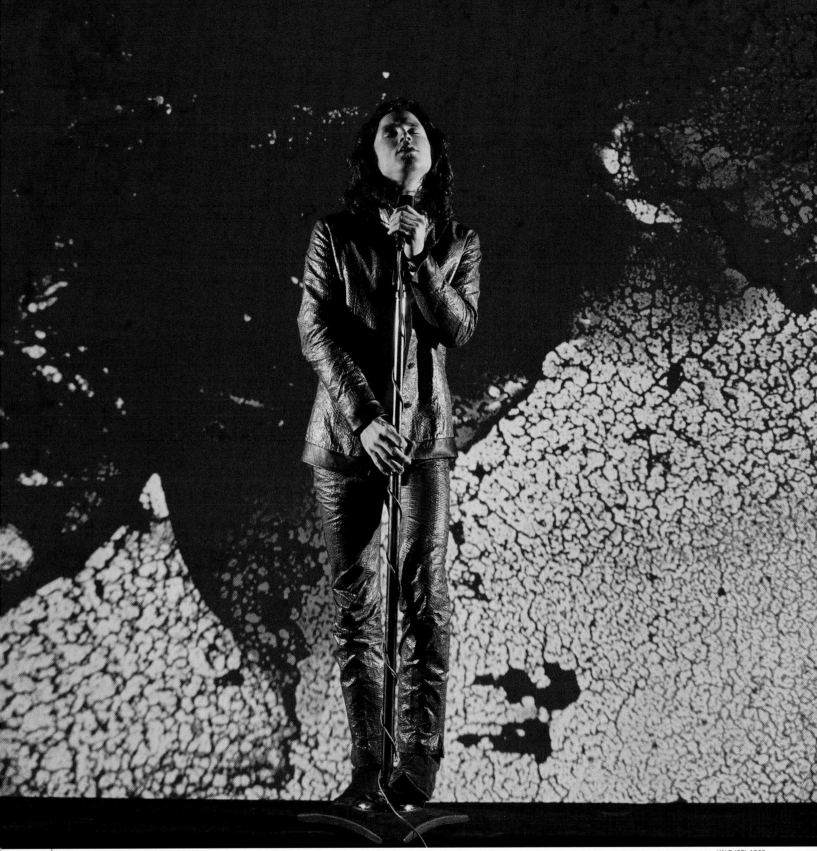

YALE JOEL 1968

▲ JIM MORRISON 1943–1971

"Looking the way he did, being born that way,
was not entirely terrible."

—GRACE SLICK

"The one who creates the most
through mass production will win.
Henry Ford has shown us how to do it."

—NIKITA KHRUSHCHEV

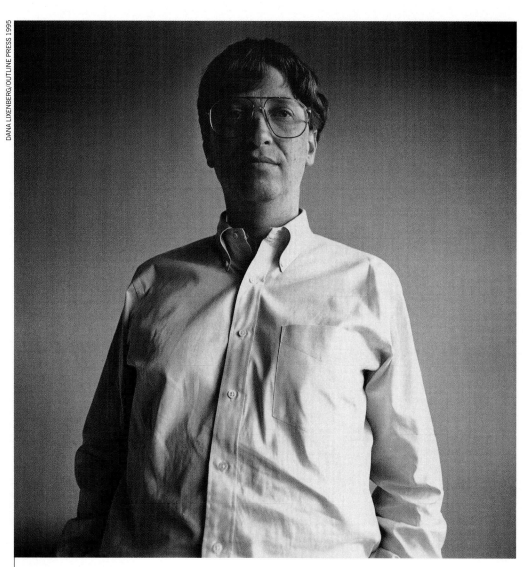

DANA LIXENBERG/OUTLINE PRESS 1995

▲ BILL GATES 1955–

"Bill Gates is the gatekeeper to be feared."

—RUPERT MURDOCH

COLLECTION OF HENRY FORD MUSEUM & GREENFIELD VILLAGE 1921

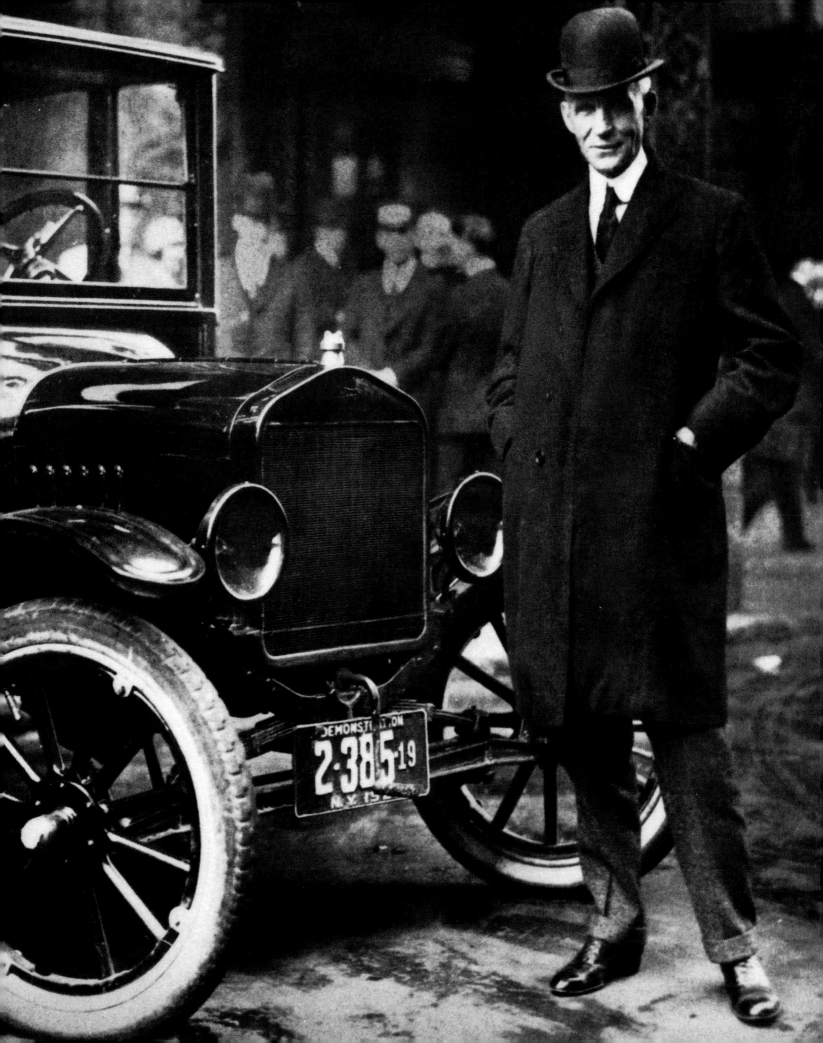

"Men make history
and not the other way around."

—HARRY S TRUMAN

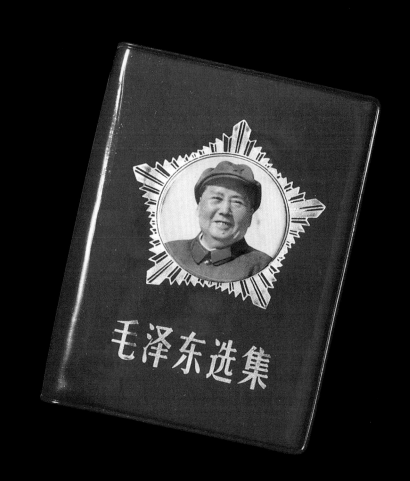

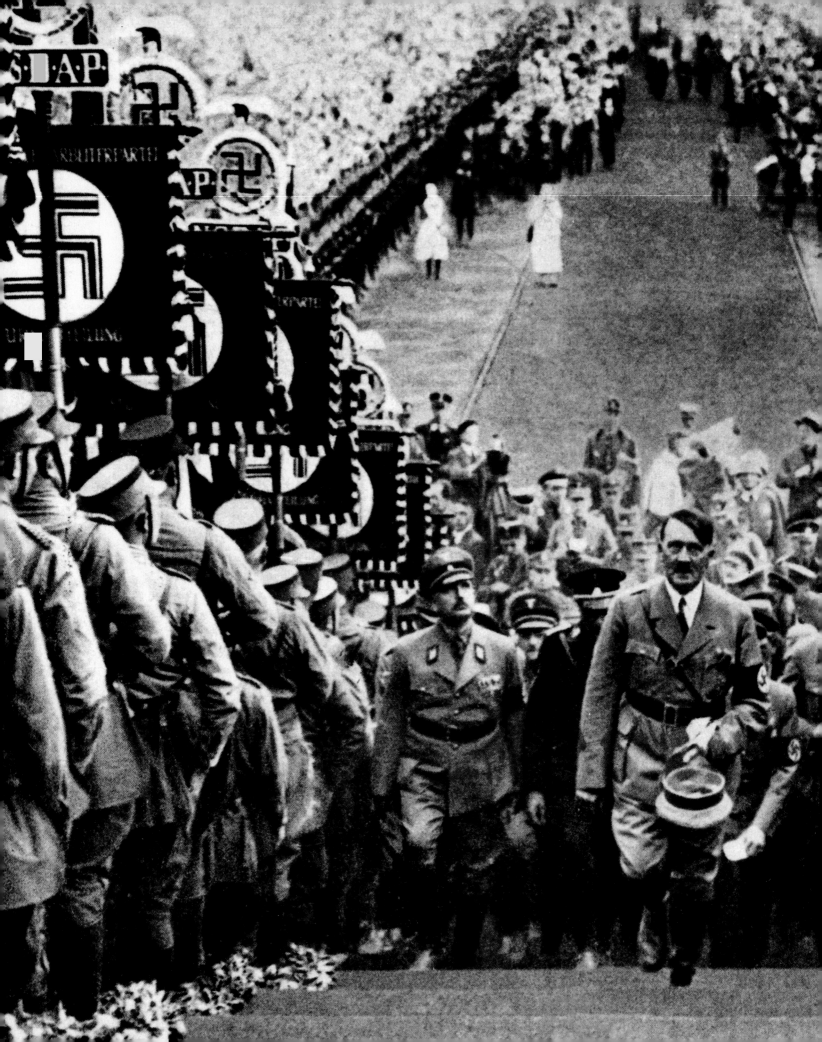

STURMABTEILUNG

STURMABTEILUNG

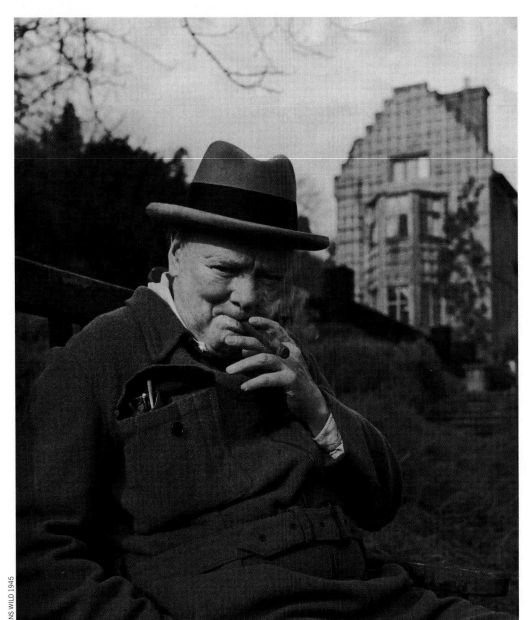

HANS WILD 1945

◄ **WINSTON CHURCHILL**
1874–1965

"[A] gallant gambler, an aristocrat, an historian, an eighteenth-century cavalry officer . . . and an indestructible juvenile."

—EDWARD R. MURROW

► **FRANKLIN DELANO ROOSEVELT**
1882–1945

"He was the only person I ever knew— anywhere—who was never afraid."

—LYNDON BAINES JOHNSON

◄ **ADOLF HITLER 1889–1945**

"We cannot yet see how deliverance will come, or when it will come, but nothing is more certain than that every trace of Hitler's footsteps, every stain of his infected and corroding fingers, will be sponged and purged and, if need be, blasted from the surface of the earth."

—WINSTON CHURCHILL

LANGDON P. MARVIN JR. CIRCA 1939

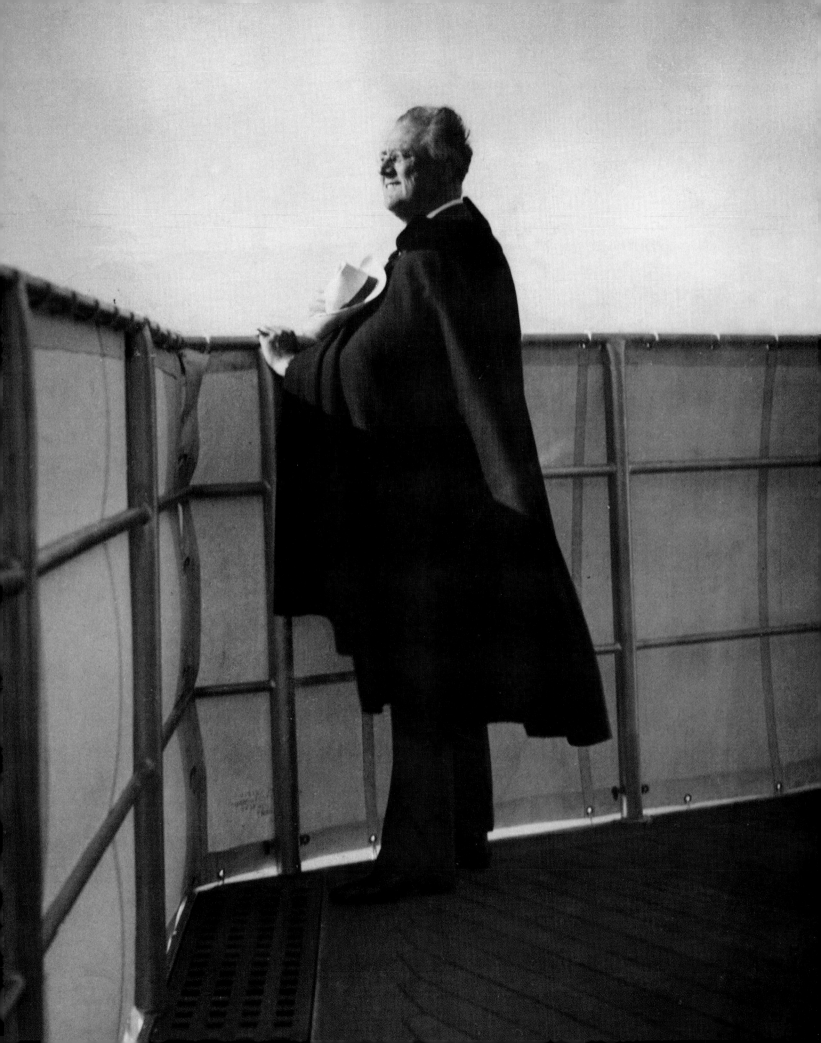

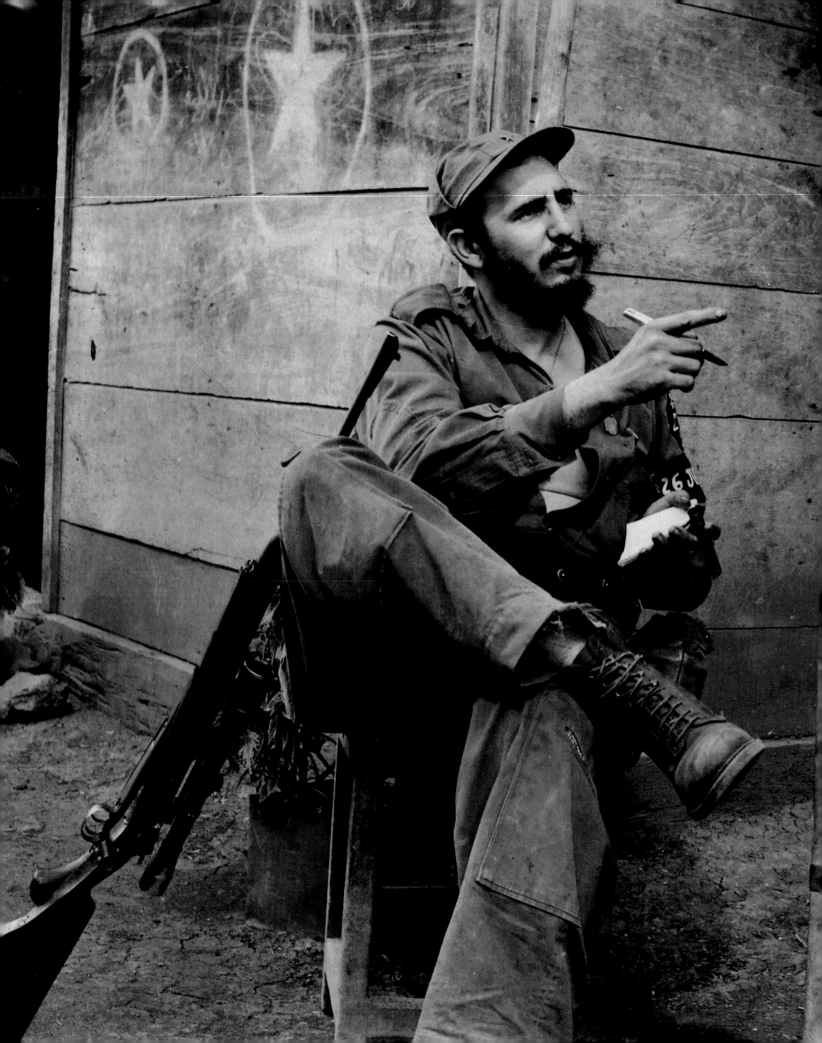

◄ FIDEL CASTRO 1926–

"Fidel is not a communist. If he were one, he would have a few more weapons."

—CHE GUEVARA

"A great
thundering
paradox
of a man,
noble and
ignoble,
inspiring and
outrageous . . .
No more
baffling,
exasperating
soldier ever
wore a
uniform."

—WILLIAM MANCHESTER

JACK WILKES 1945

▲ MAO TSE-TUNG 1893–1976

"'Think about it,' he said [to me]. 'You have two hundred
million people, and we have seven hundred million.'"

—NIKITA KHRUSHCHEV

▲ **V.I. LENIN** **1870–1924**

"I informed him that I could not co-operate with a regime that persecuted anarchists . . . His reply was that my attitude was *bourgeois sentimentality* . . . Russia was igniting the world revolution, and here I was lamenting over a little blood-letting."

—EMMA GOLDMAN

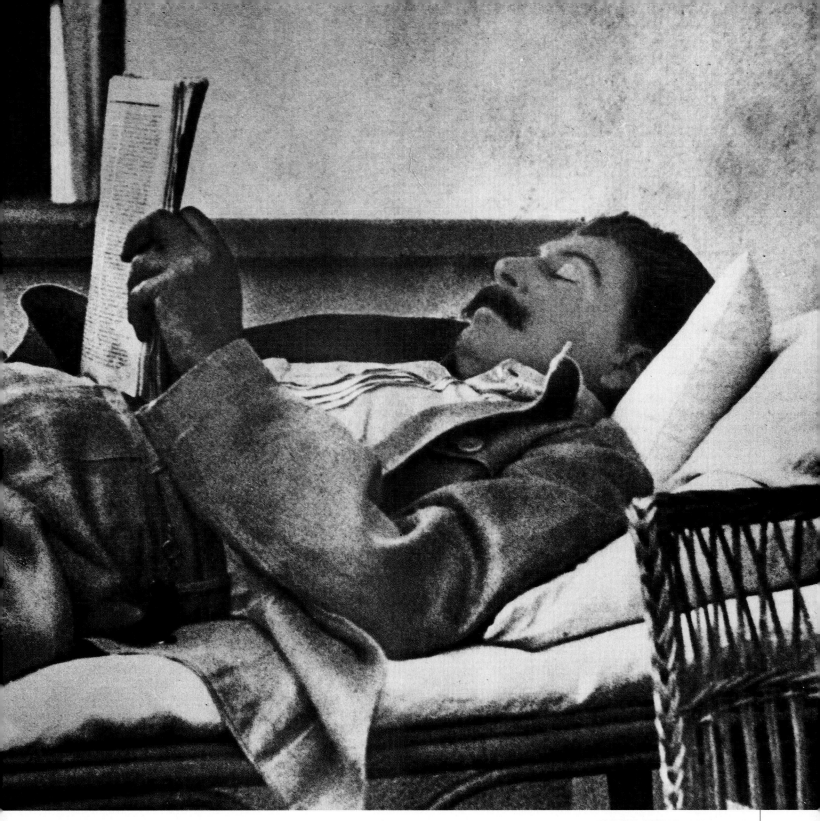

"To choose one's victim, to prepare one's plans minutely, to stake an implacable vengeance, and then to go to bed . . . there is nothing sweeter in the world."

—JOSEPH STALIN

"If you want something from an audience, you give blood to their fantasies."

—MARLON BRANDO

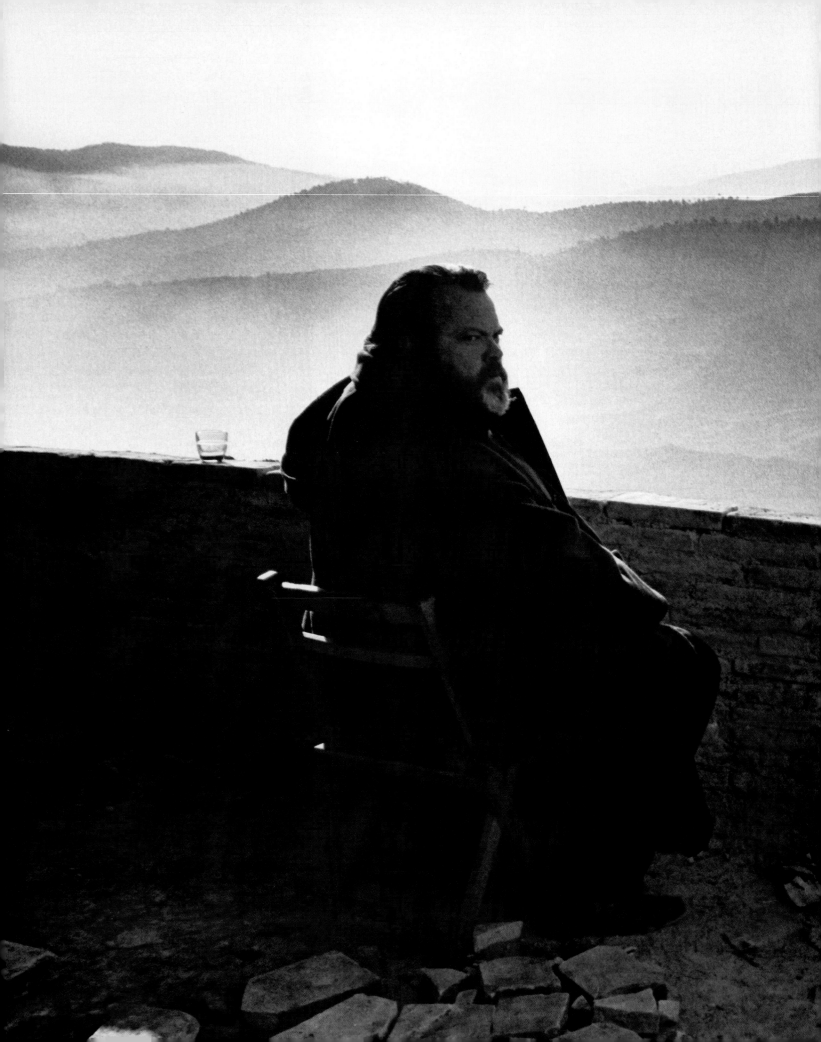

"I honestly think that **broken nose** made his fortune . . . It gave him **sex appeal**. He was too beautiful before."

—IRENE SELZNICK

◄ ORSON WELLES
1915–1985

"When I have seen him
and talked with him,
I feel like a plant
that has been watered."

—MARLENE DIETRICH

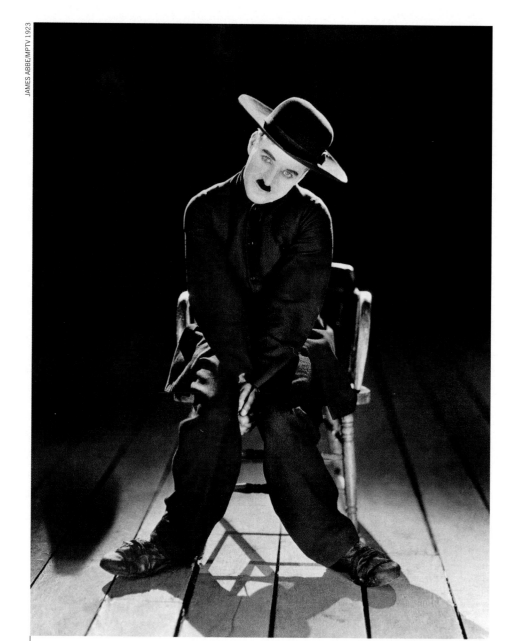

▲ CHARLIE CHAPLIN 1889–1977

"The son of a bitch is a ballet dancer . . . He's the best ballet dancer that ever lived, and if I get a good chance, I'll kill him with my bare hands."

—W.C. FIELDS

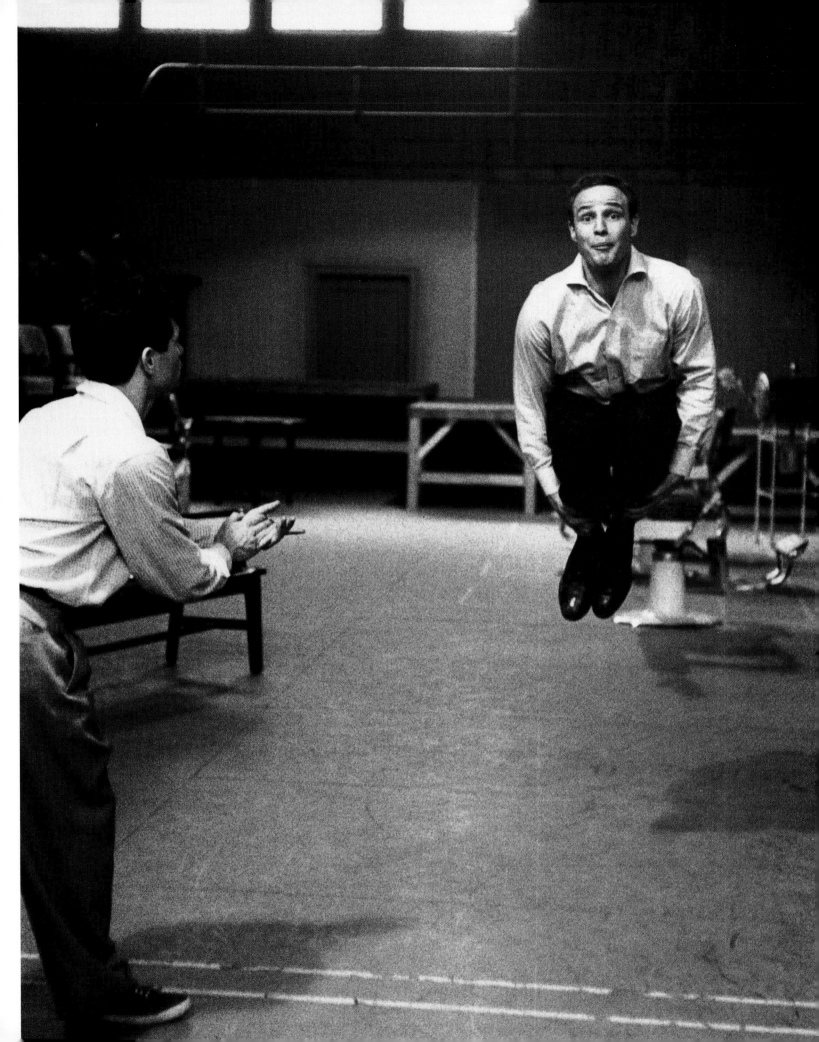

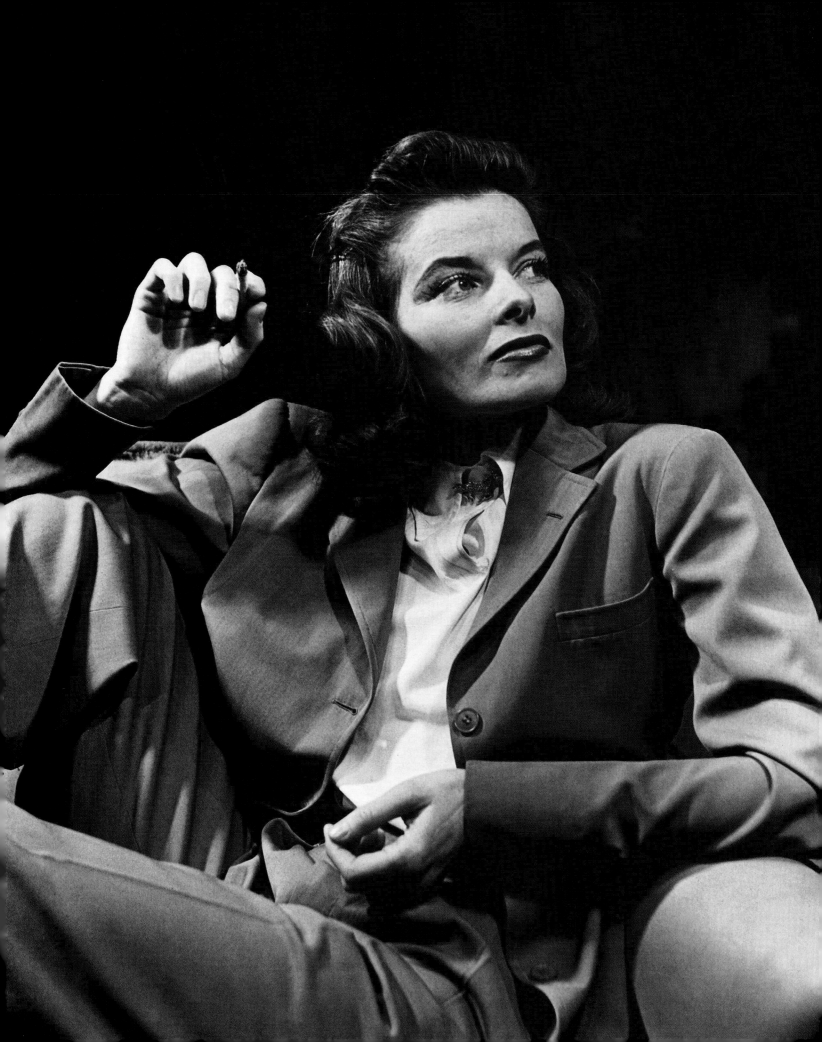

"I have not lived as a woman.
I have lived as a man.
I've just done
what I
damn well
wanted to
and I've made enough money
to support myself and
I ain't afraid of being alone."

—KATHARINE HEPBURN

"I know that every time I have seen Marlene Dietrich ever, it has done something to my heart and made me happy. If this makes her mysterious then it is a fine mystery."

—ERNEST HEMINGWAY

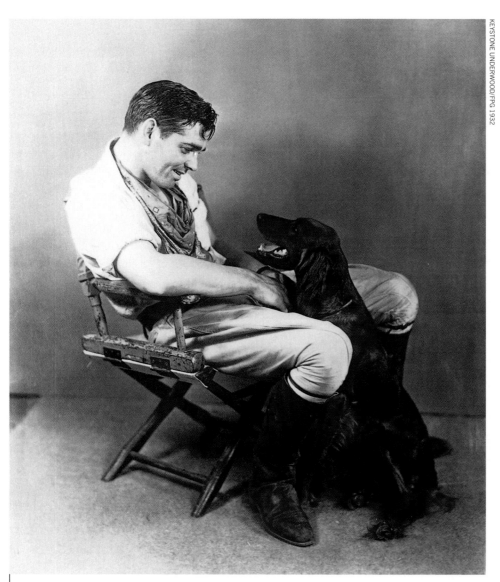

KEYSTONE UNDERWOOD/FPG 1932

▲ CLARK GABLE 1901–1960

"No complexes, no inhibitions, no fixations, no phobias."

—ADELA ROGERS ST. JOHNS

KOBAL COLLECTION 1932

78

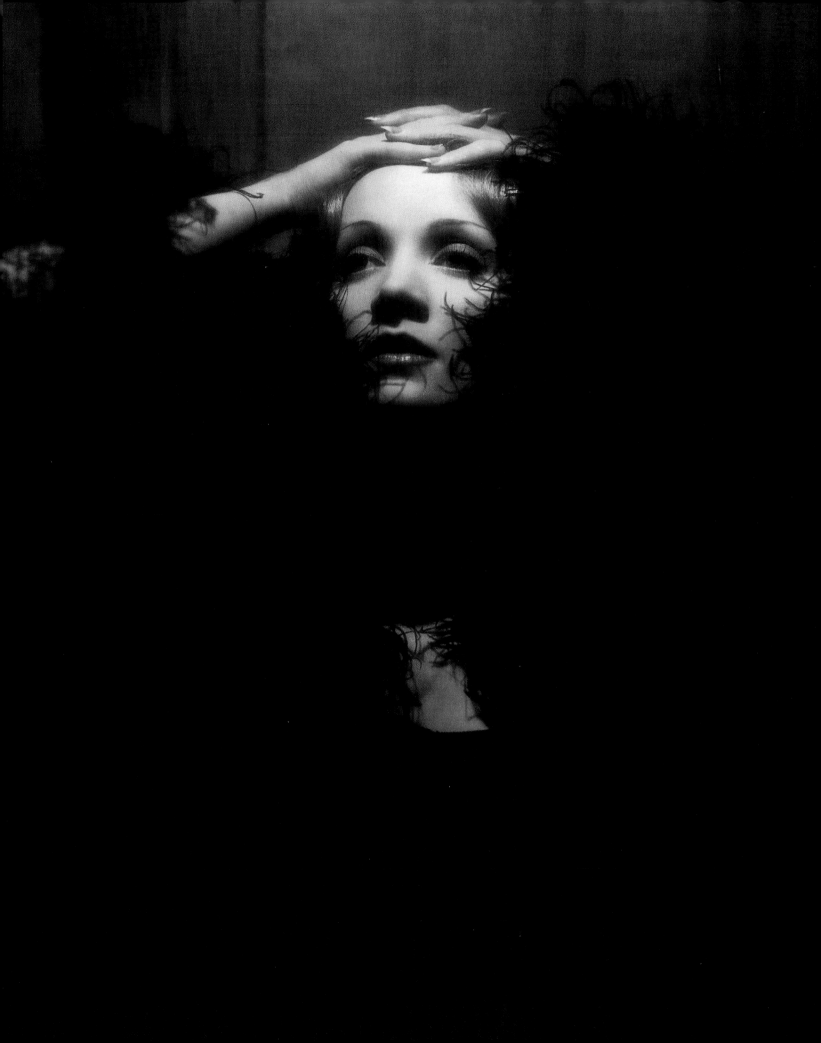

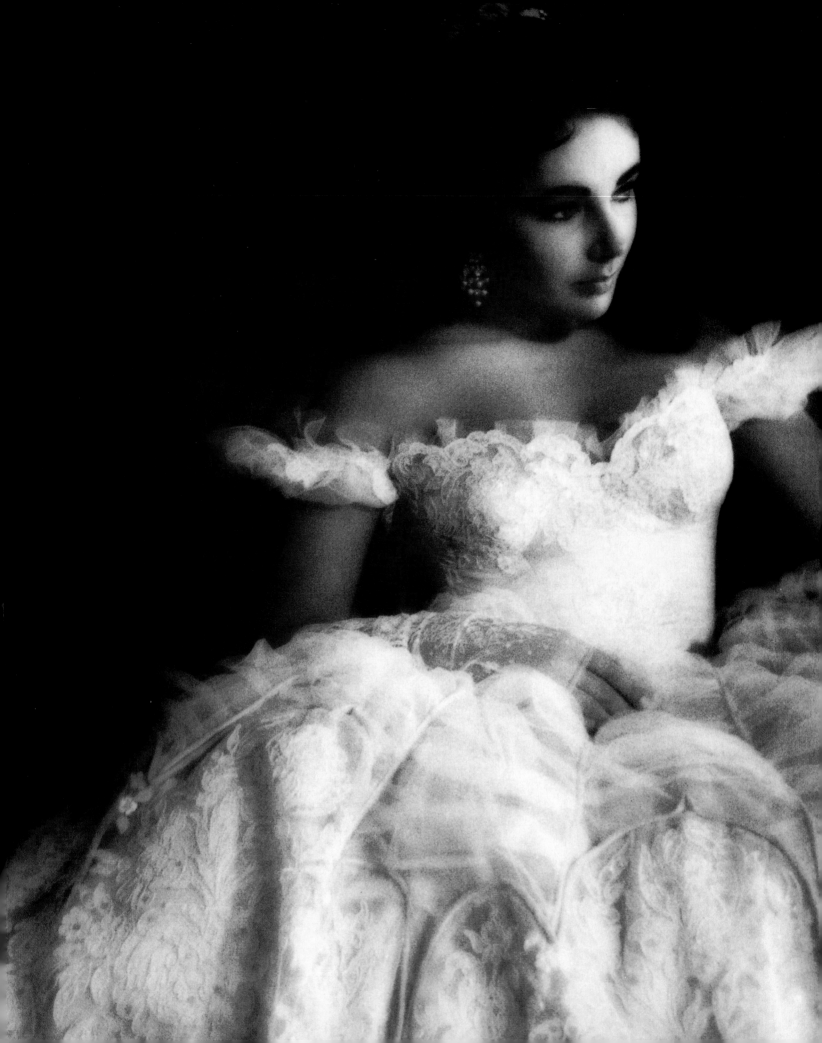

◄ ELIZABETH TAYLOR 1932–

"A wondrous
light radiates
from her,
and it always
takes
my
breath
away."

—MADONNA

81

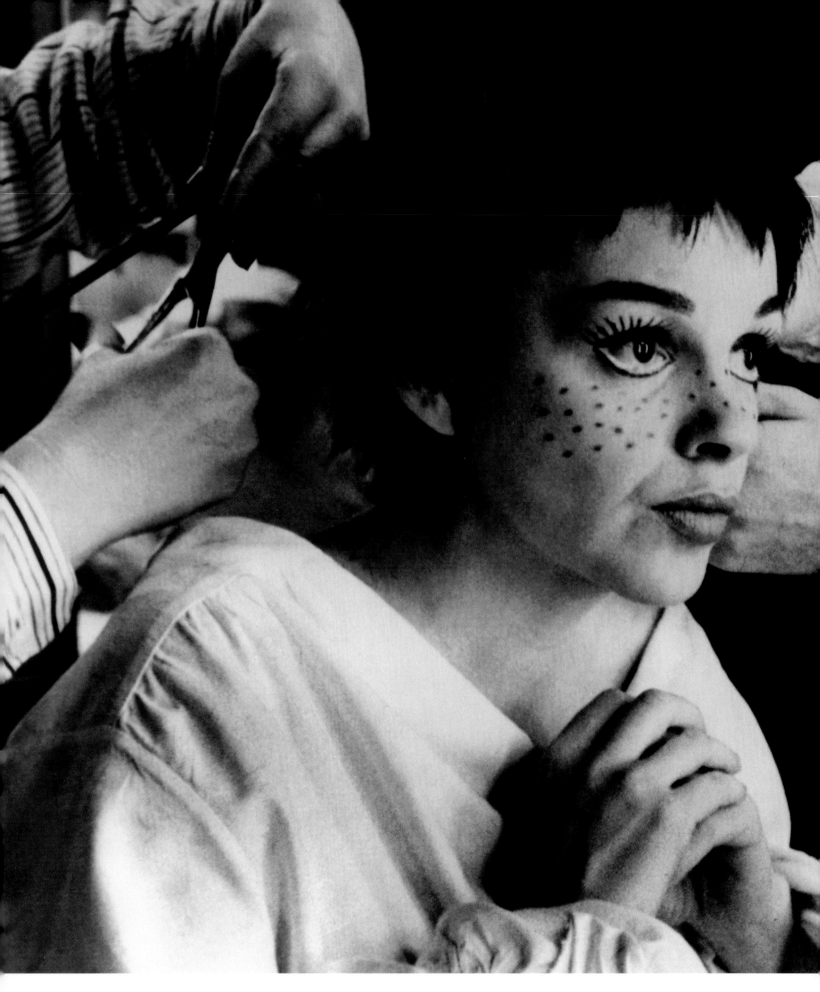

◄ JUDY GARLAND 1922–1969

"One minute I was onstage with my mother, the next moment I was onstage with Judy Garland. One minute she smiled at me, and the next minute she was like the lioness that owned the stage and suddenly found somebody invading her territory . . . The killer instinct of a performer had come out in her."

—LIZA MINNELLI

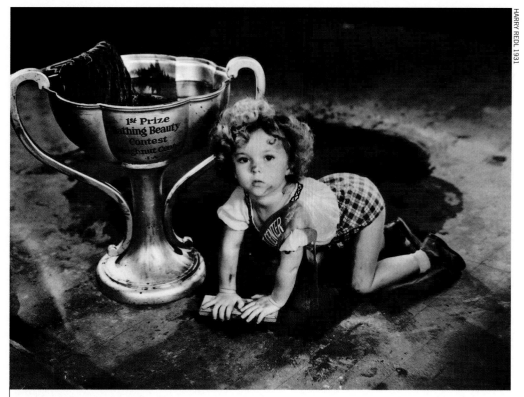

▲ SHIRLEY TEMPLE 1928–

"She's Ethel Barrymore at six!"

—ADOLPHE MENJOU

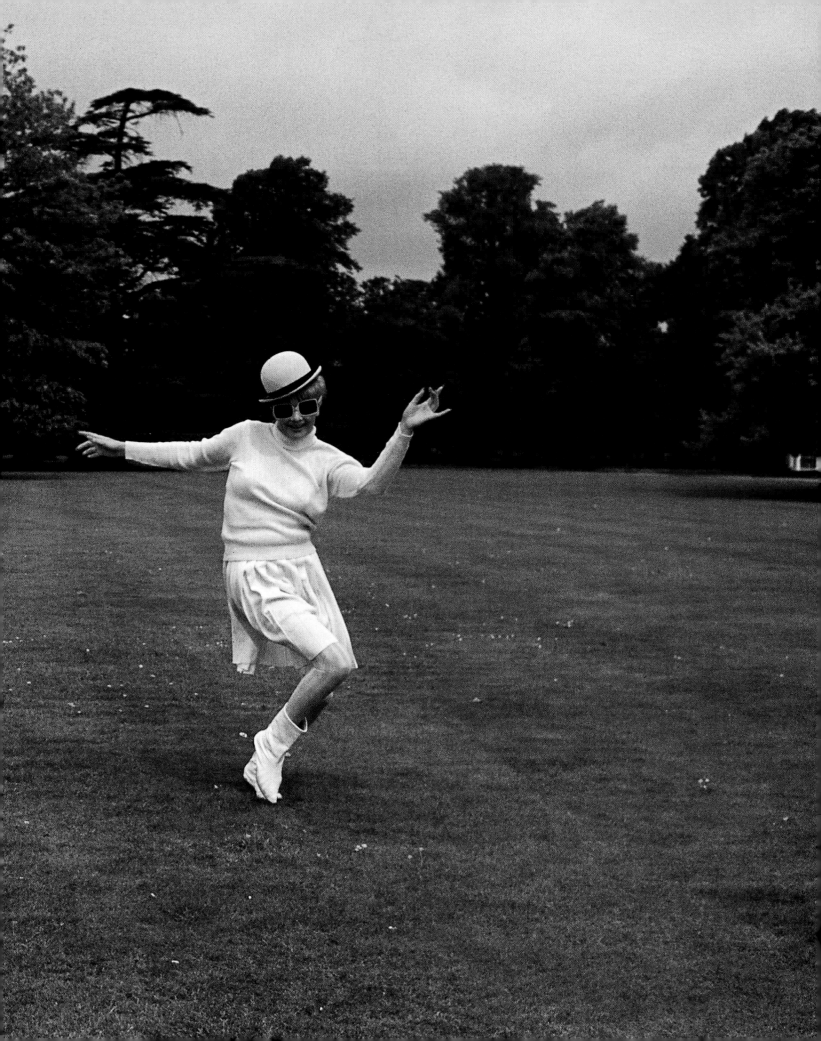

"Positive, sensitive, optimistic, and not a *bad* cook."

—LUCIE ARNAZ

"When all these people started showing up outside . . . I complained to the producer. Jimmy overheard me and said, 'Don't forget, Raquel, they're the ones who buy the tickets,' and then he'd go off signing these autographs and getting his picture taken alongside Joe and Betty from Ohio."

—RAQUEL WELCH

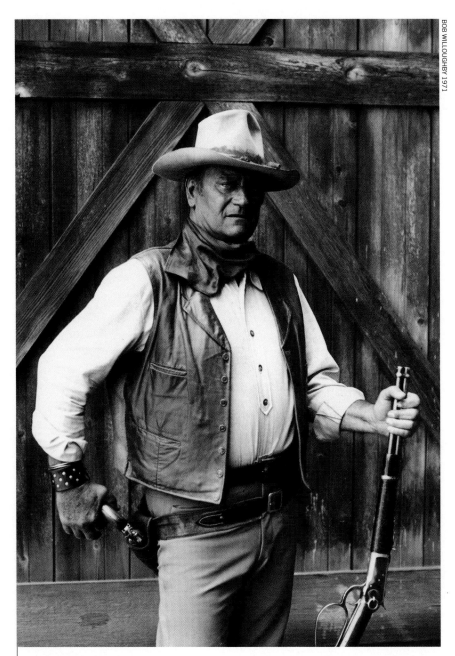

BOB WILLOUGHBY 1971

▲ JOHN WAYNE 1907–1979

"Dammit, the s.o.b. looked like a *man.*"

—RAOUL WALSH

JOHN BRYSON 1964

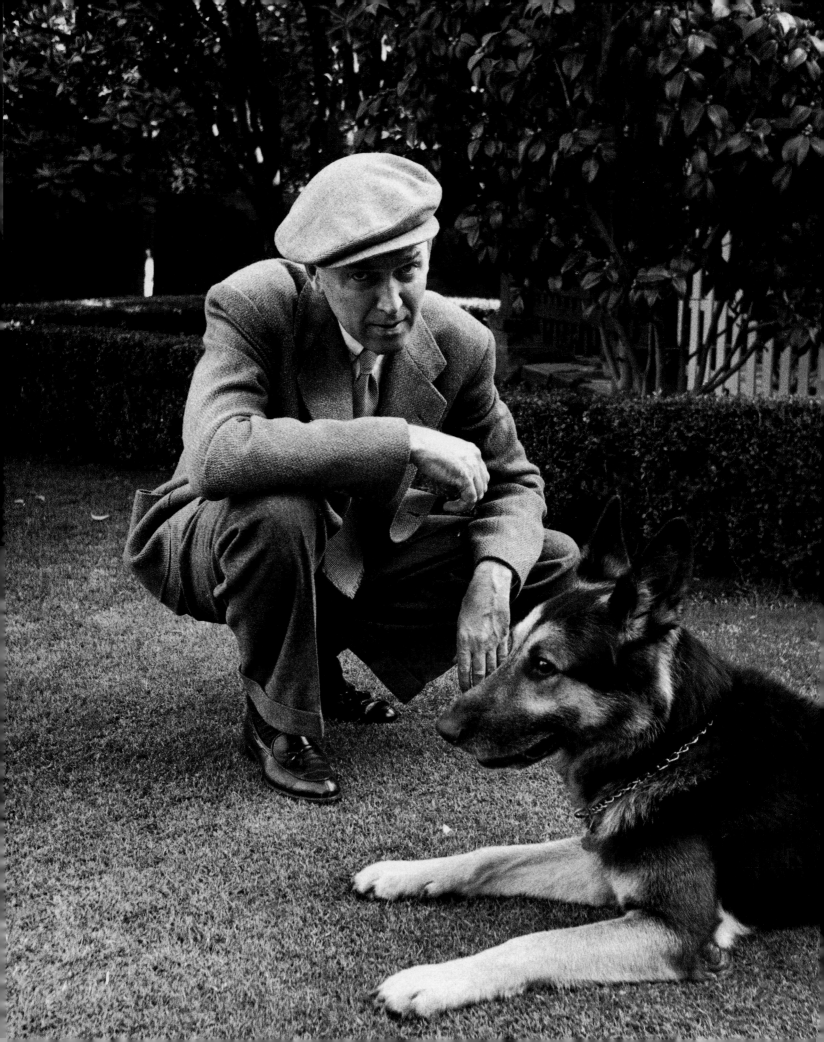

"Music is a means of Rapid Transportation."[1]

—JOHN CAGE

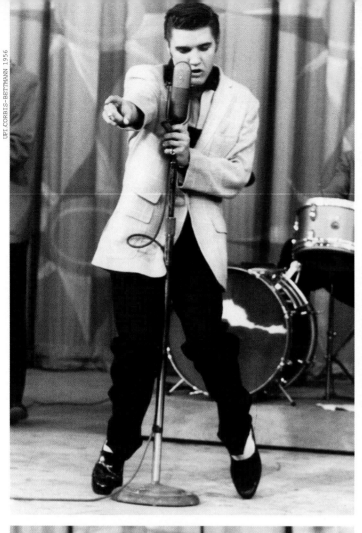

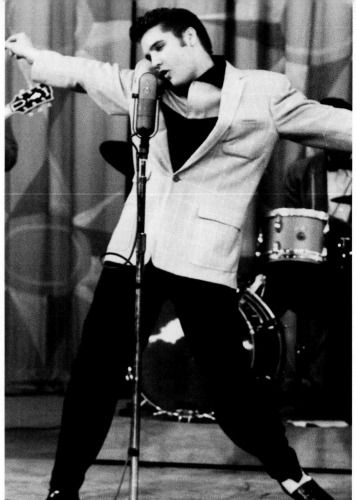

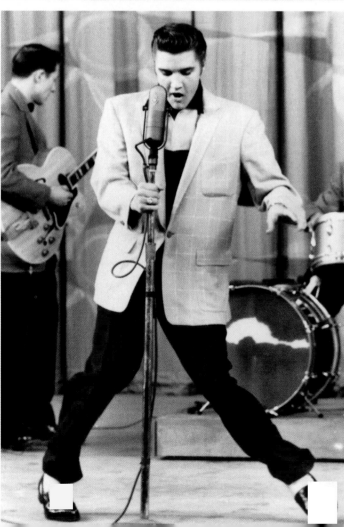

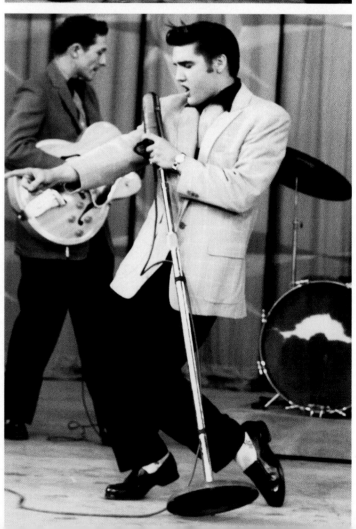

"He can't last. I tell you flatly, he can't last."

—JACKIE GLEASON

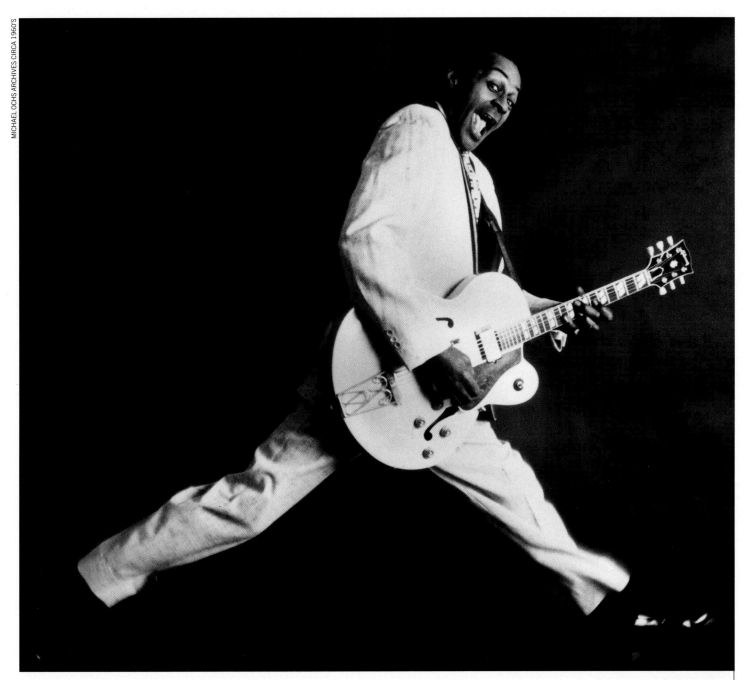

MICHAEL OCHS ARCHIVES CIRCA 1960'S

▲ CHUCK BERRY 1926–

"[My mama] said, 'You and Elvis are pretty good, but you're no Chuck Berry.'"

—JERRY LEE LEWIS

"She could express more emotion in one chorus than most actresses can in three acts."

—JEANNE MOREAU

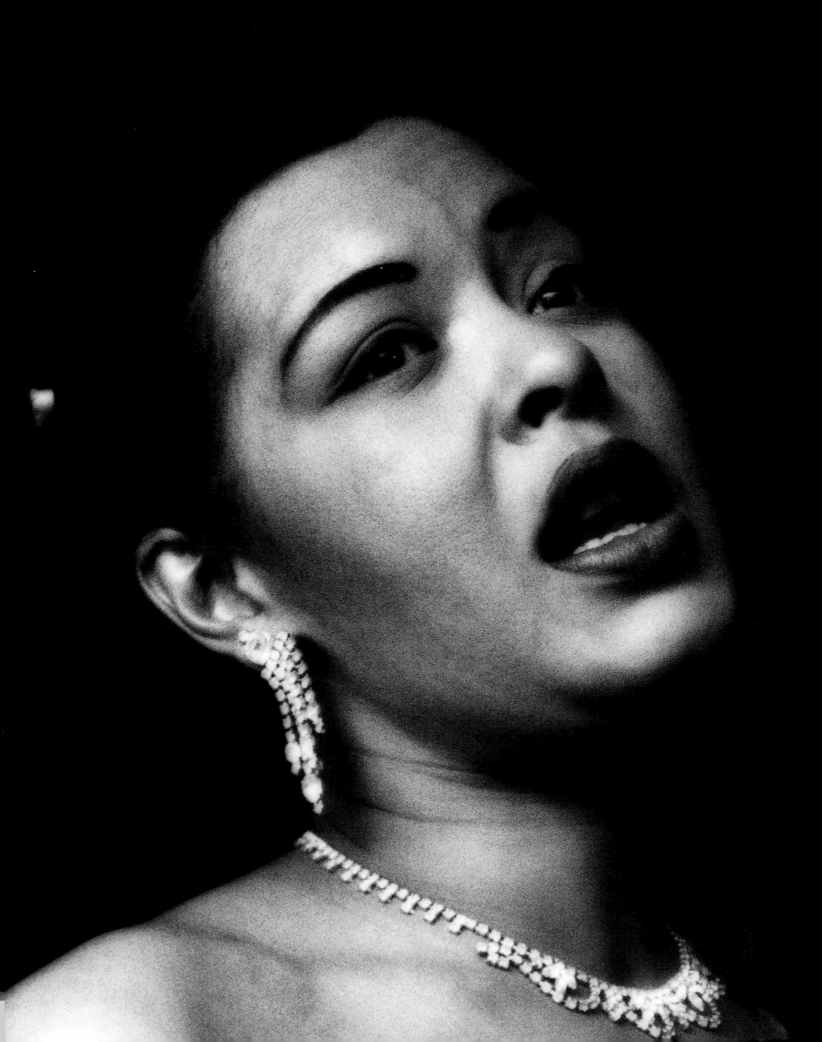

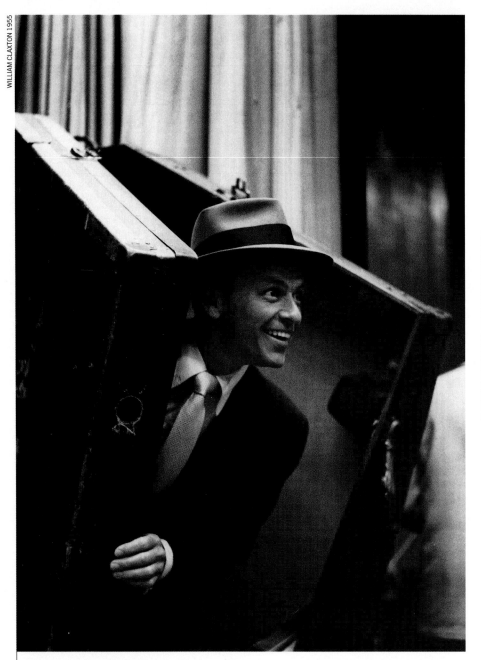

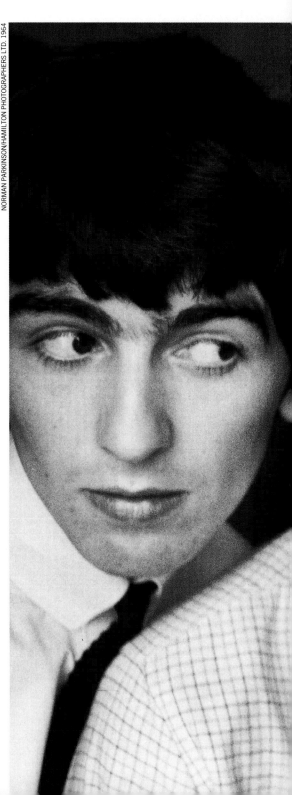

▲ **FRANK SINATRA 1915–**

"This very thin guy . . . had been waiting tables
when suddenly he climbed onto the stage . . .
[and] sang only eight bars when I felt the
hair on the back of my neck rising."

—HARRY JAMES

"I declare that the Beatles are mutants. Prototypes of evolutionary agents sent by God with a mysterious power to create a new species—a young race of laughing freemen."

—TIMOTHY LEARY

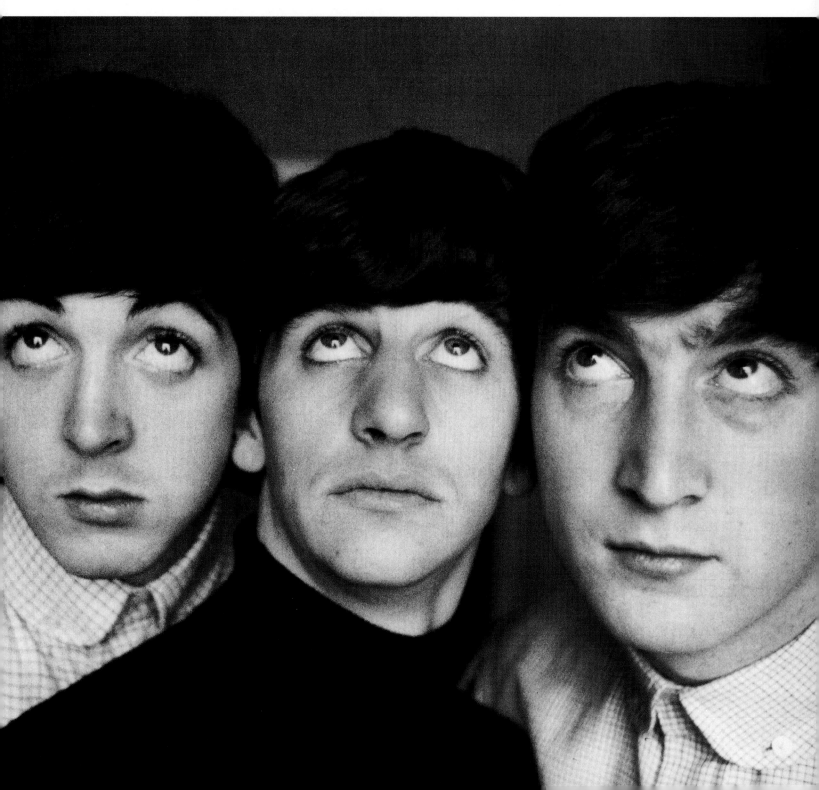

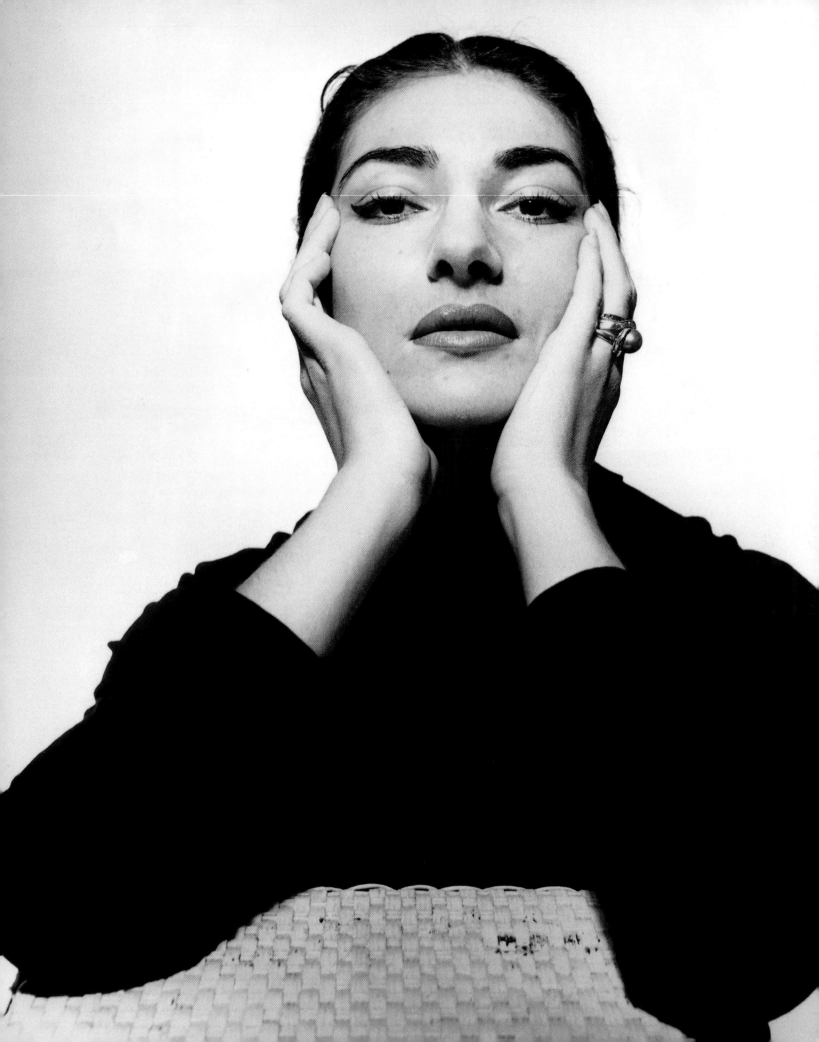

"Beauty . . . Intensity, expression, everything.
She was a monstrous phenomenon. Almost a sickness— the kind of actress that has passed for all time."

—LUCHINO VISCONTI

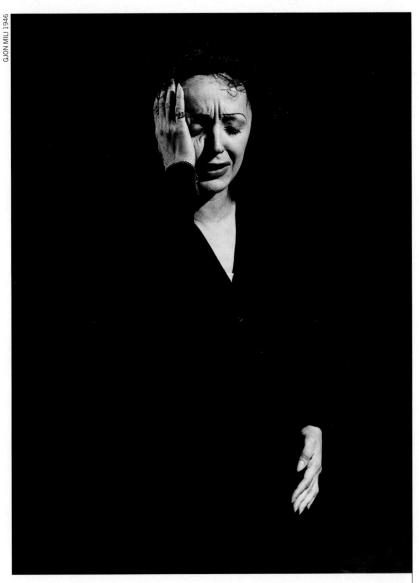

▶ LOUIS ARMSTRONG
1901–1971

"I loved and respected Louis Armstrong. He was born poor, died rich, and never hurt anyone on the way."

—DUKE ELLINGTON

▲ EDITH PIAF 1915–1963

"All that was left of Piaf was all that had ever counted—her immense, infallible voice, which rose to the roof, carrying its enormous authentic outcry . . ."

—JANET FLANNER

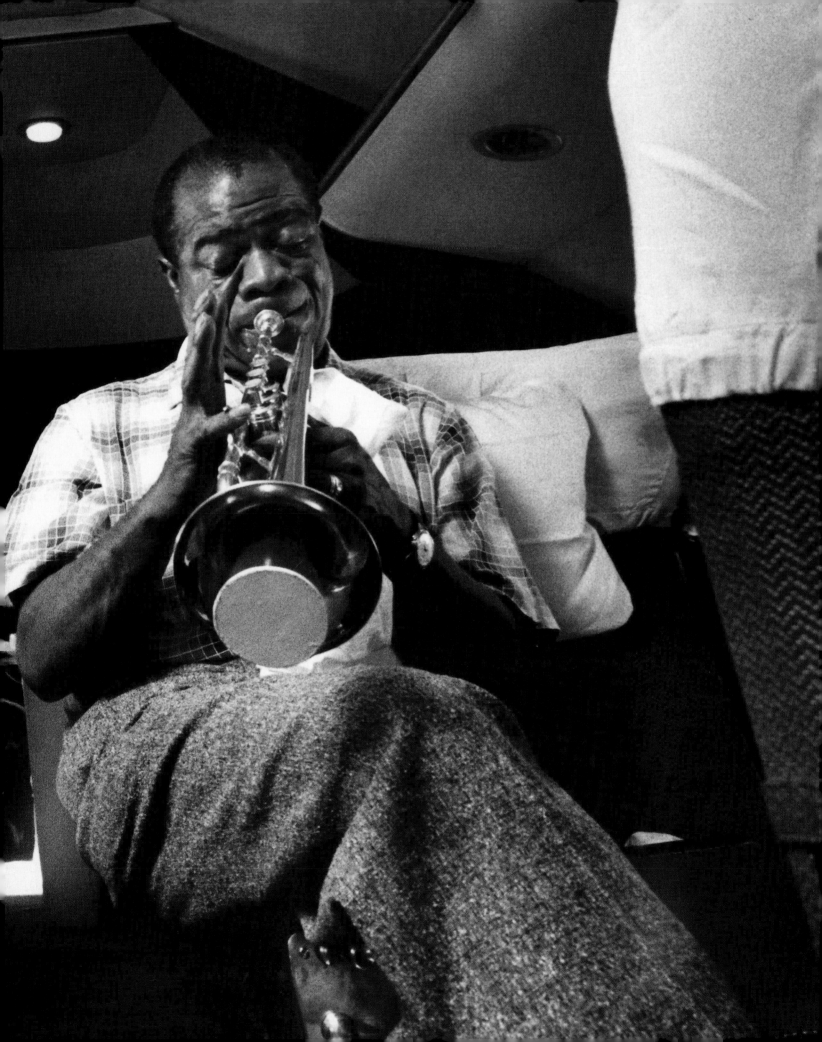

"The only one who can **beat me** is me."

—MICHAEL JOHNSON

SONJA HENIE'S SKATES

▶ **SONJA HENIE 1912–1969**

"On the rink,
she was a princess,
a flying angel,
a quicksilver
goddess."

—DARRYL ZANUCK

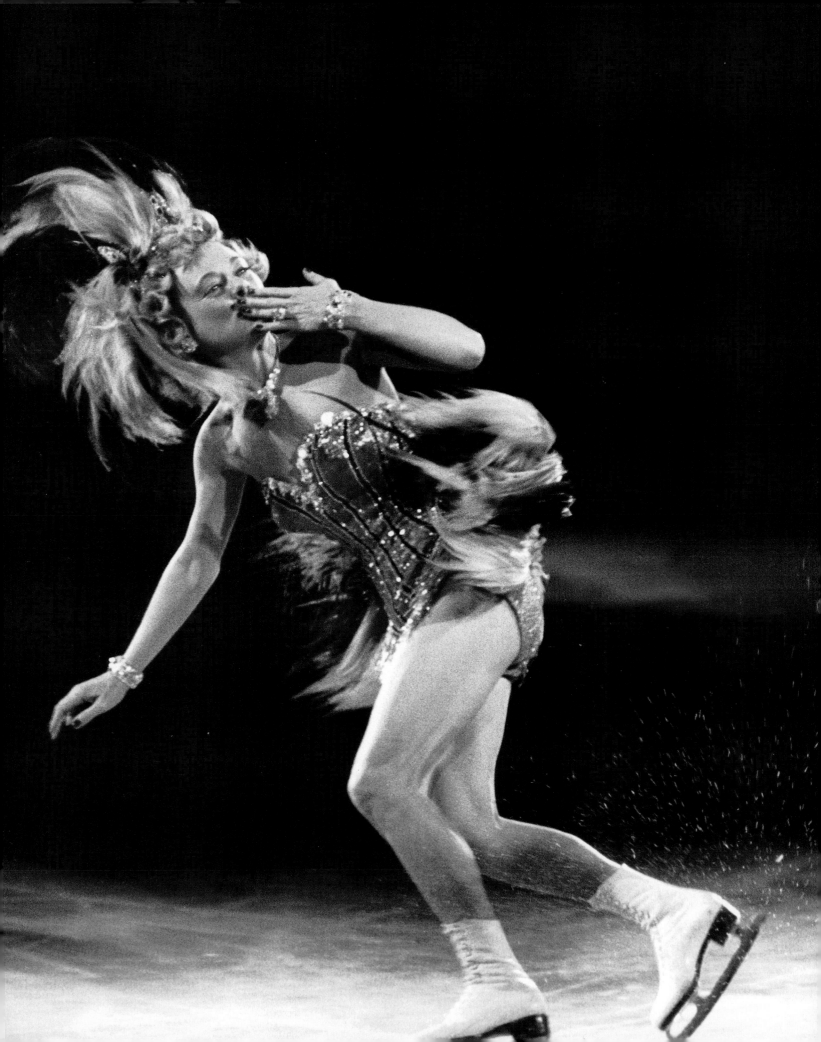

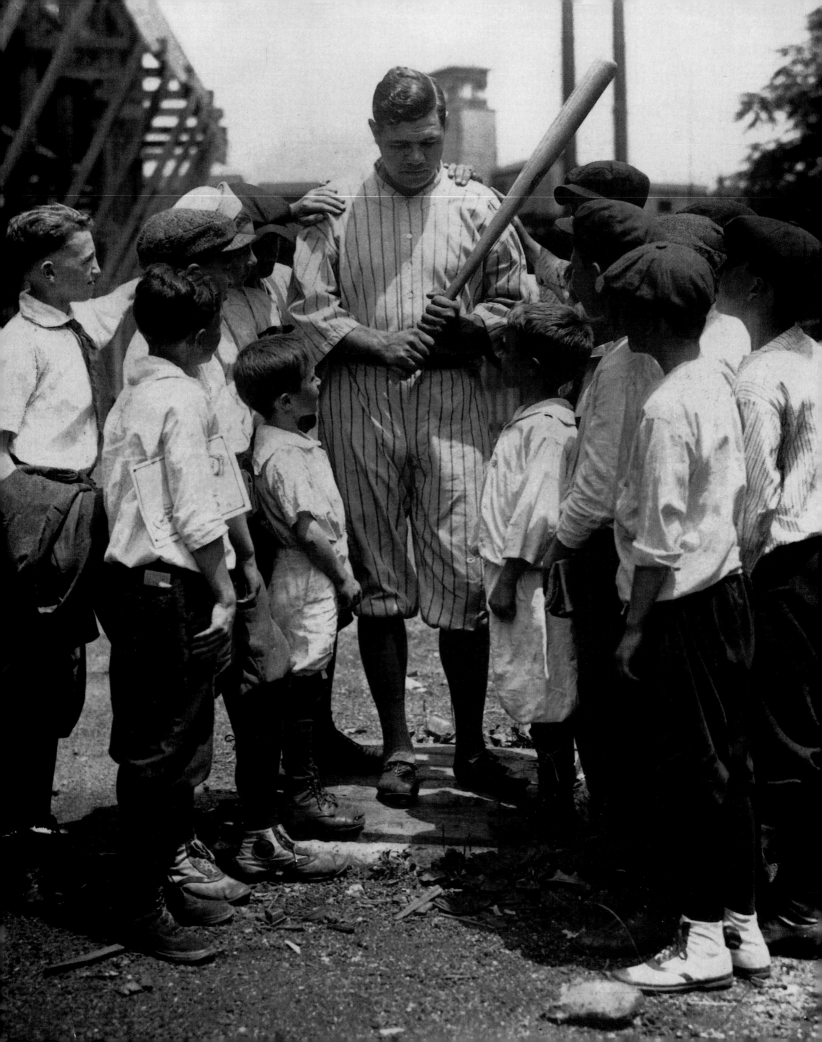

◄ **BABE RUTH** 1895–1948

"Who is this Baby Ruth? And what does she do?"

—GEORGE BERNARD SHAW

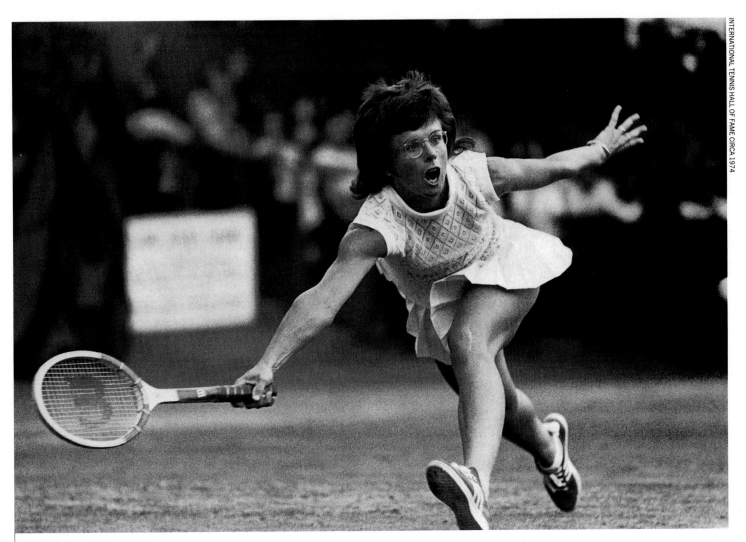

▲ **BILLIE JEAN KING** 1943–

"I will not be remembered for winning Wimbledon on my first try, but 'There's the guy who lost to Billie Jean King in front of ninety million people!' "

—BOBBY RIGGS

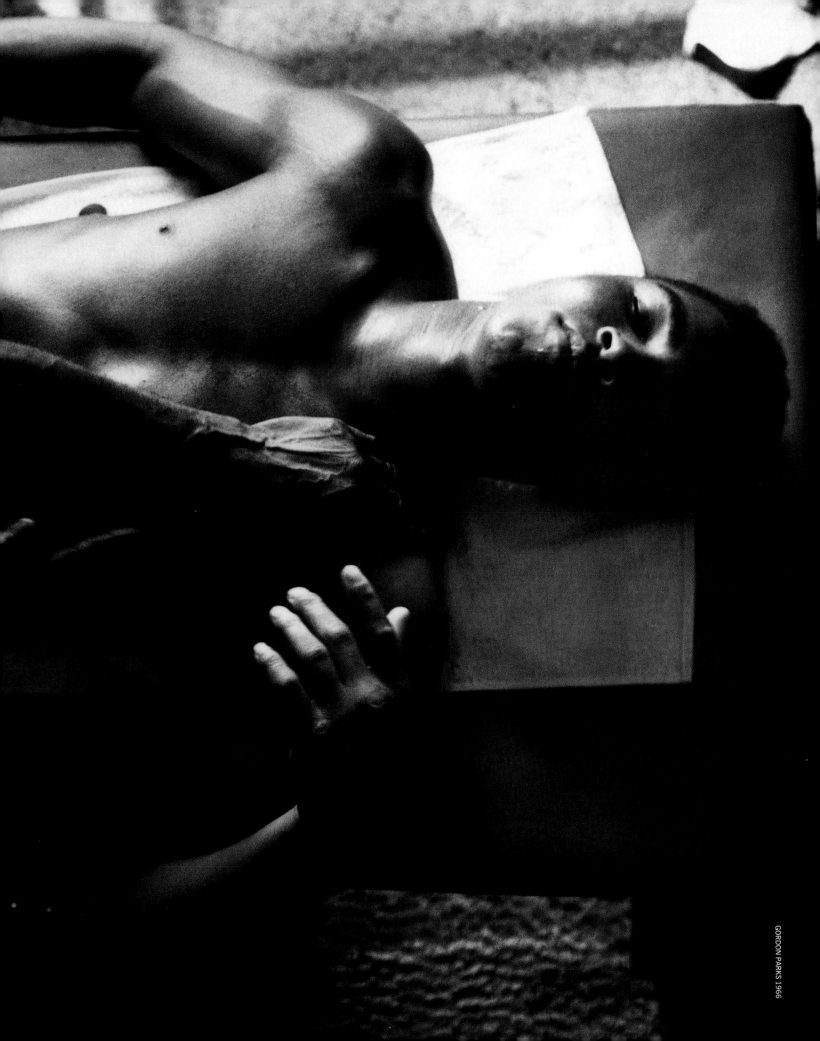

◄ **MUHAMMAD ALI 1942–**

"Do you understand what it did for black Americans to know that the most physically gifted, possibly the most handsome, and one of the most charismatic men in the world was black?"

—REGGIE JACKSON

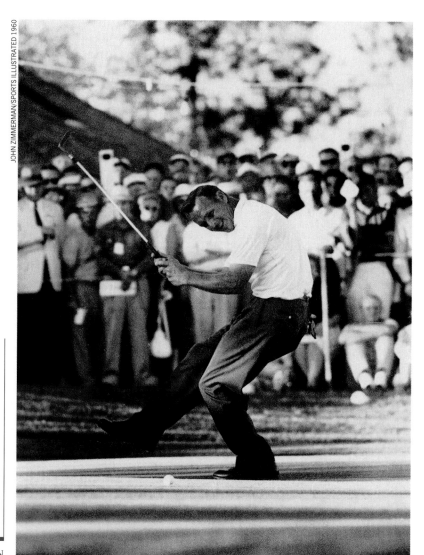

► **ARNOLD PALMER 1929–**

"Of all the perks of office, the one I've enjoyed most is playing 18 holes of golf with Arnold Palmer."

—BILL CLINTON

► **MICHAEL JORDAN 1963–**

"He is God disguised as Michael Jordan."

—LARRY BIRD

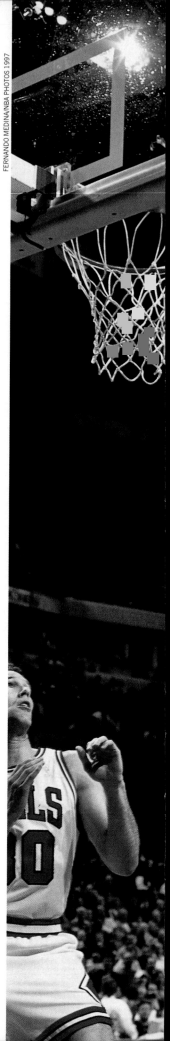

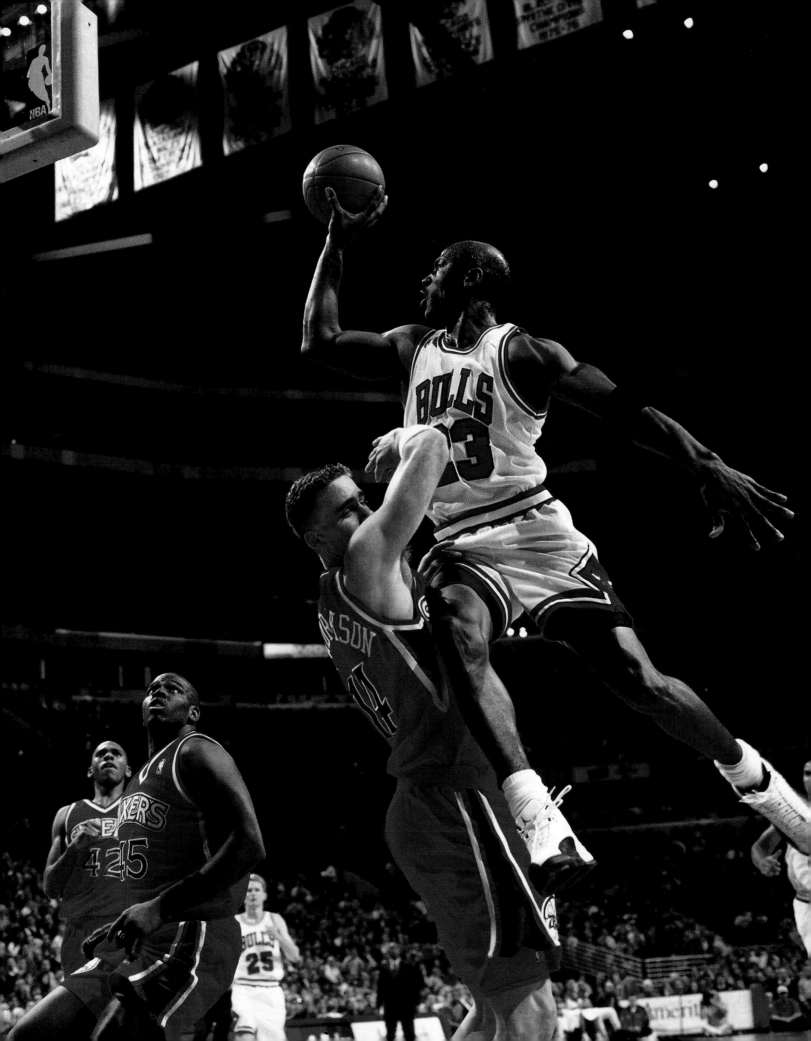

"Joe himself has declared that his kid brother, Dominic, is a better fielder than he. Which always recalls the occasion when the Red Sox were playing the Yanks and Dom fled across the county line to grab a drive by Joe that no one but a DiMaggio could have reached. And the late Sid Mercer, shading his thoughtful eyes under a hard straw hat, remarked to the press box at large:

'Joe should sue his old man on that one.'"

—RED SMITH

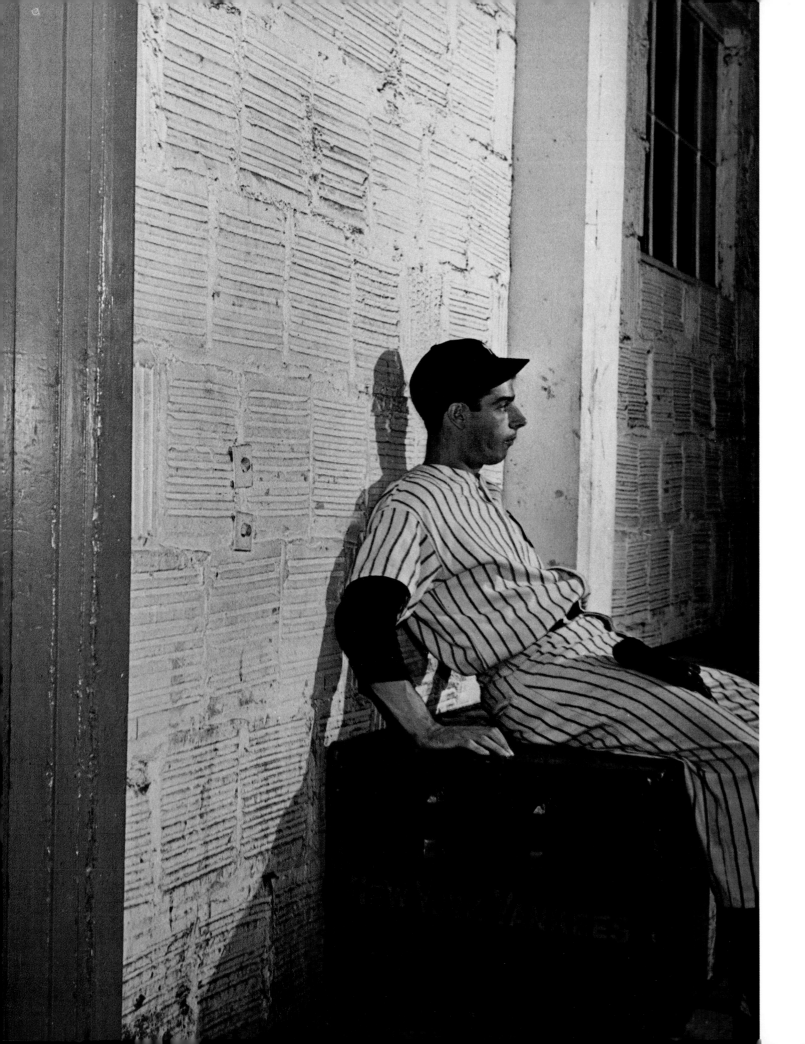

"Neither man nor nation can exist without a sublime idea."

—FYODOR DOSTOYEVSKY

THE CAT IN THE HAT'S HAT

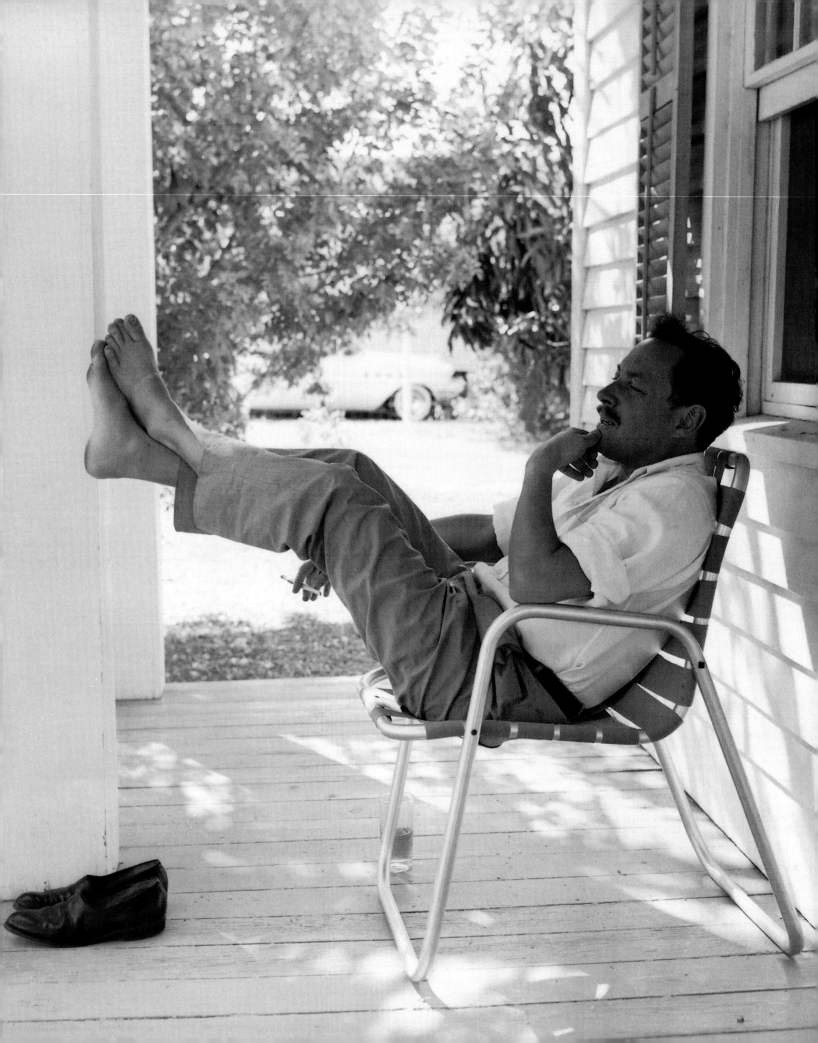

◄ **TENNESSEE WILLIAMS 1911–1983**

"He would get up, silent and remote from whoever happened to be with him, dress in a bathrobe, **mix himself a double dry martini**, put a cigarette in his long white holder, **sit before his typewriter**, grind in a blank sheet of paper, **and so become Tennessee Williams.**"

—ELIA KAZAN

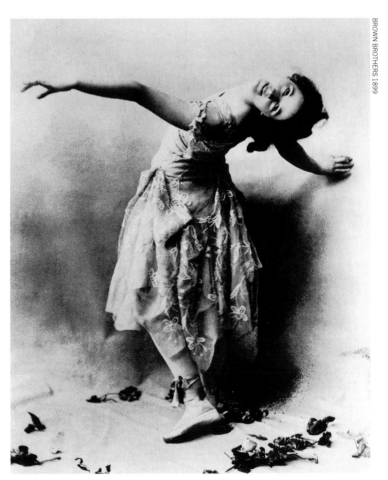

► **ISADORA DUNCAN 1877–1927**

"I beheld the dance I had always dreamed of . . . satisfying every sense as a flower does, or a phrase of Mozart's."

—EDITH WHARTON

▶ **ALBERT EINSTEIN 1879–1955**

"Do you realize
that Einstein
is a scientist who
**needs no
laboratory**,
no equipment, no
tools of any kind?
He just sits in an
empty room with a
pencil and a piece
of paper and his
brain."

—DAVID BEN-GURION

116

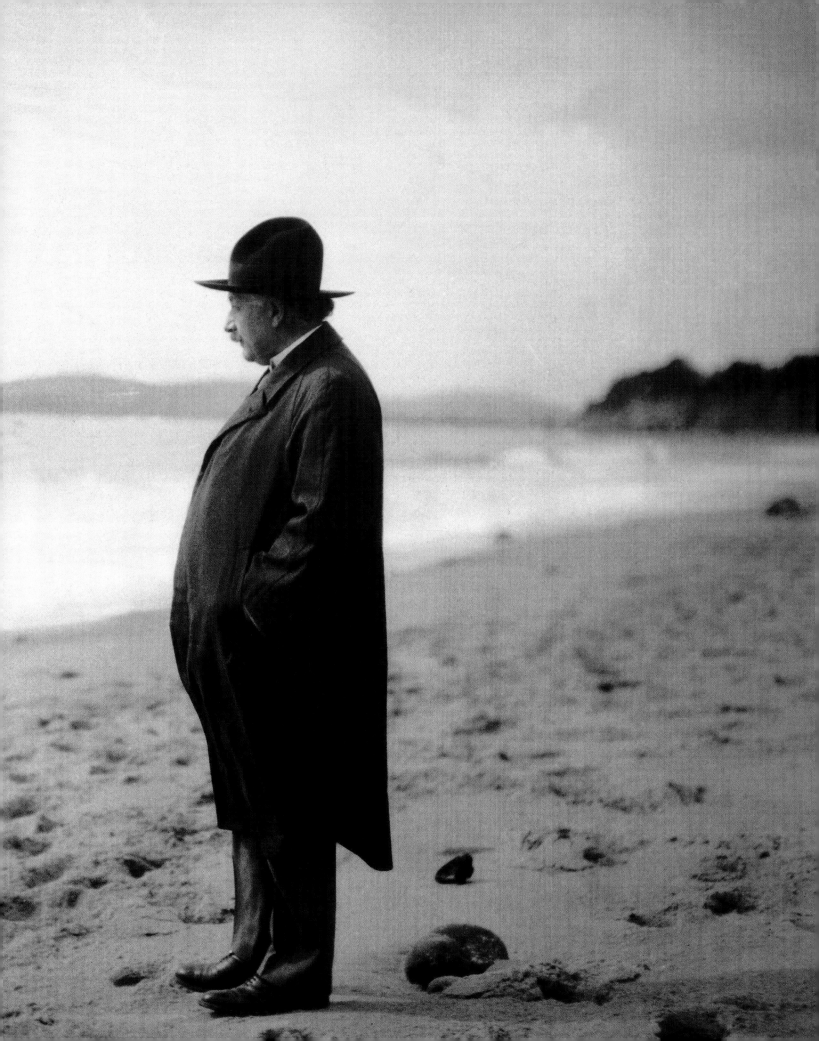

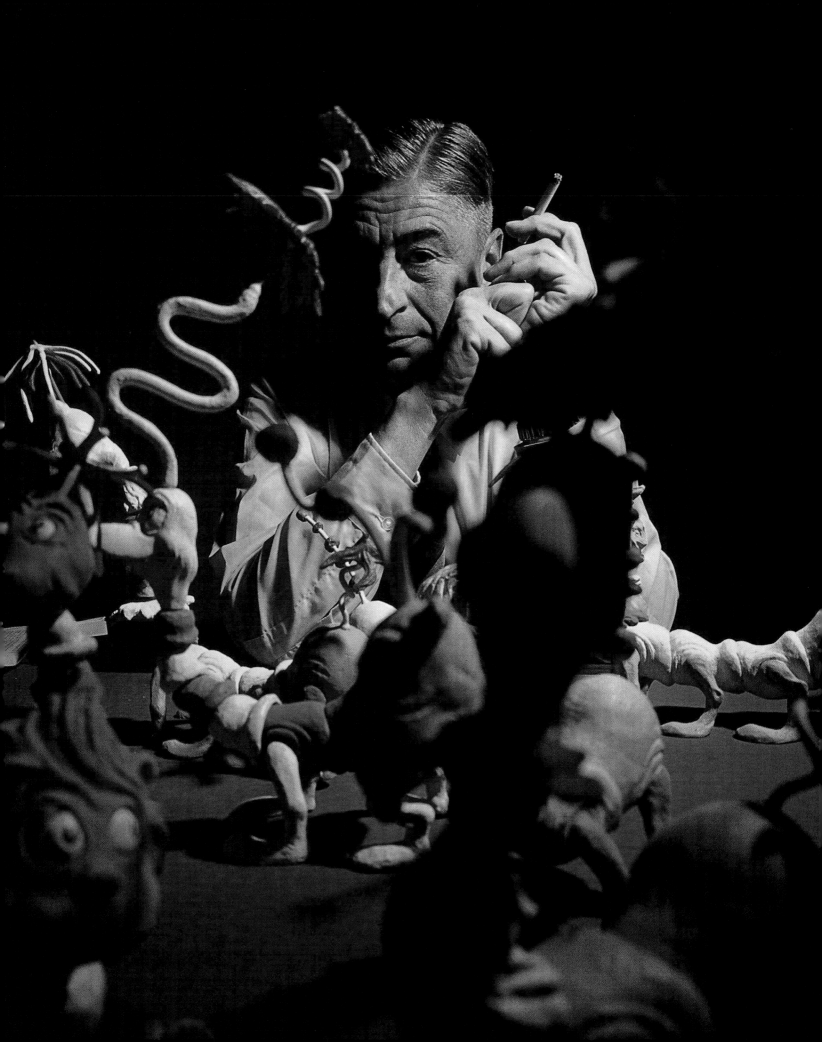

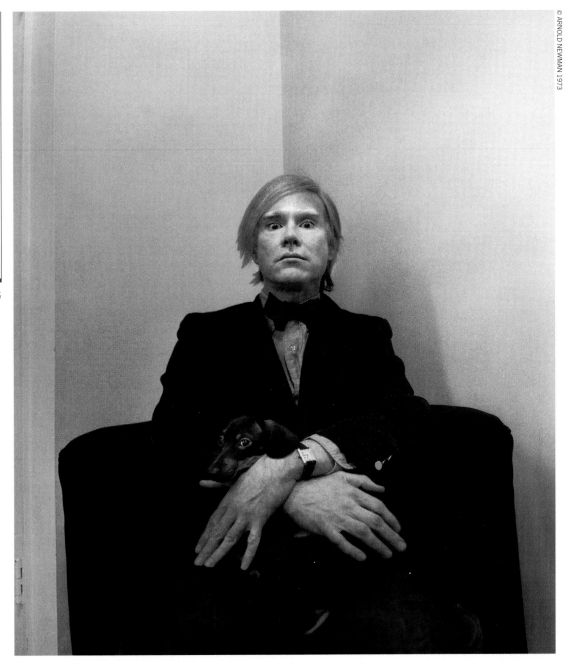

► **ANDY WARHOL**
1928–1987

"You're a killer
of art, you're
a killer of
beauty, and
you're even a
killer of laughter.
I can't bear
your work!"

—WILLEM DE KOONING

◄ **DR. SEUSS 1904–1991**

"He is remembered for the murder of Dick and Jane,
which was a mercy killing of the highest order."

—ANNA QUINDLEN

"When I was a child my mother said to me, 'If you become a soldier you'll be a general. If you become a monk you'll end up as the pope.' Instead I became a painter and wound up as Picasso."

—PABLO PICASSO

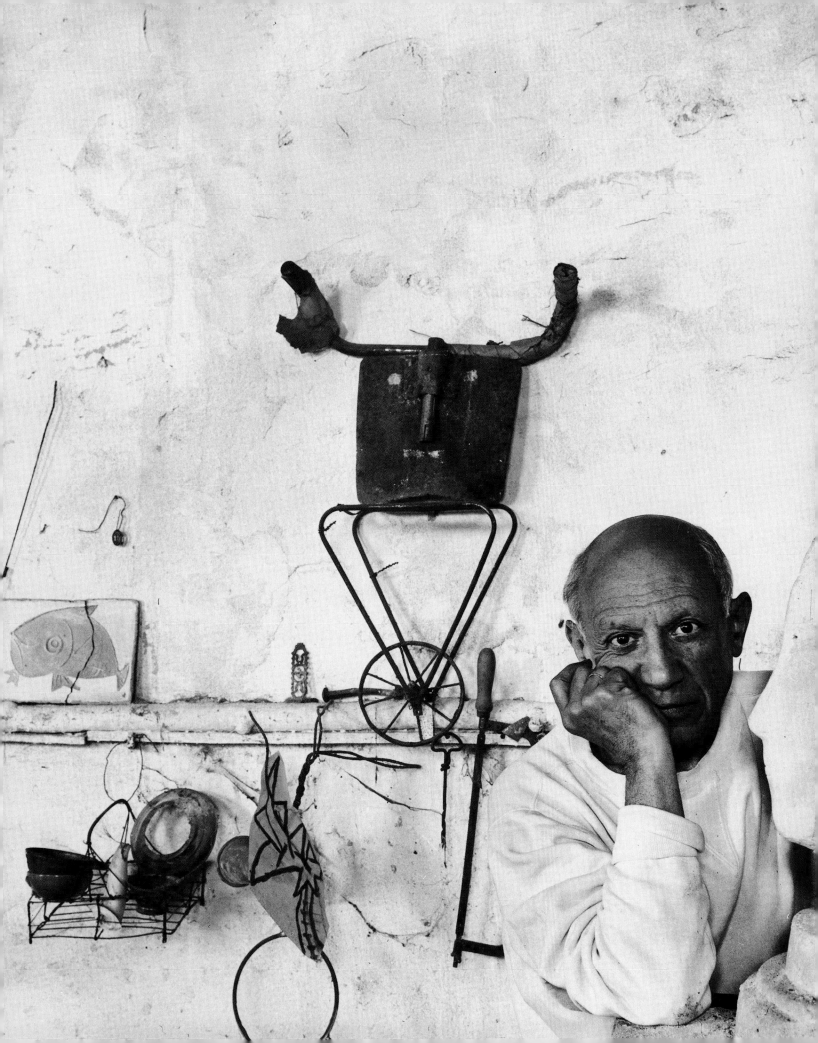

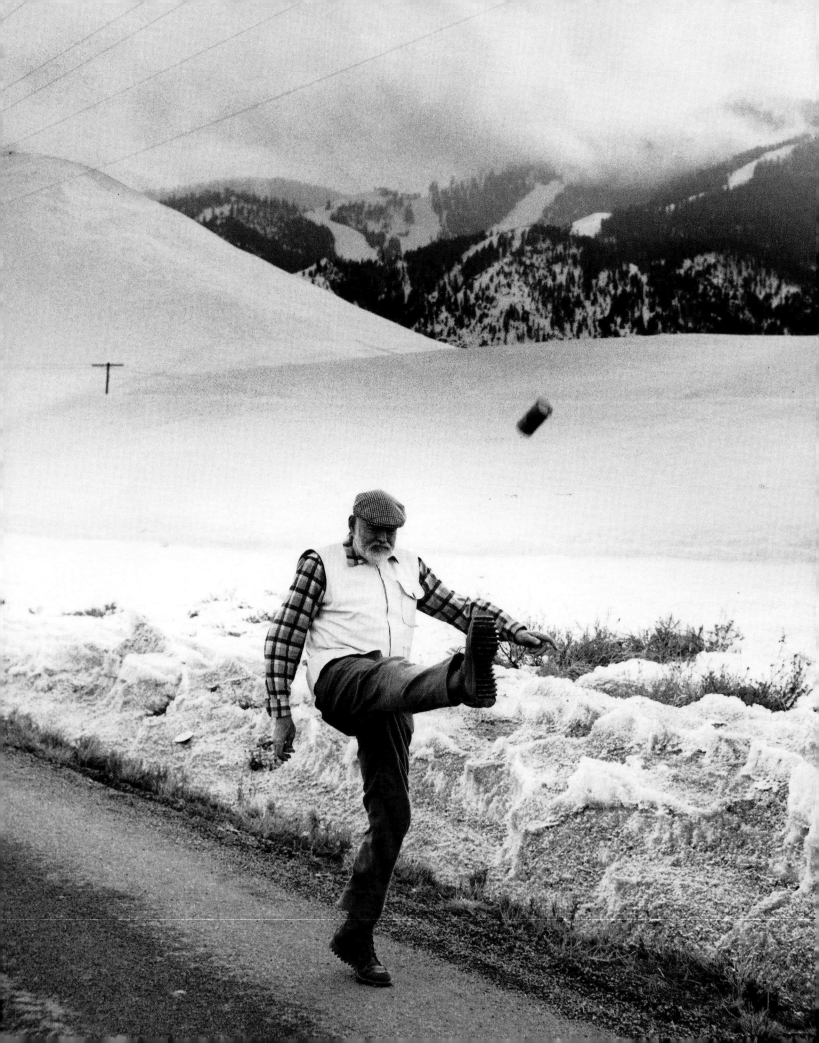

"Wearing underwear
is as formal as I ever hope to get."

—ERNEST HEMINGWAY

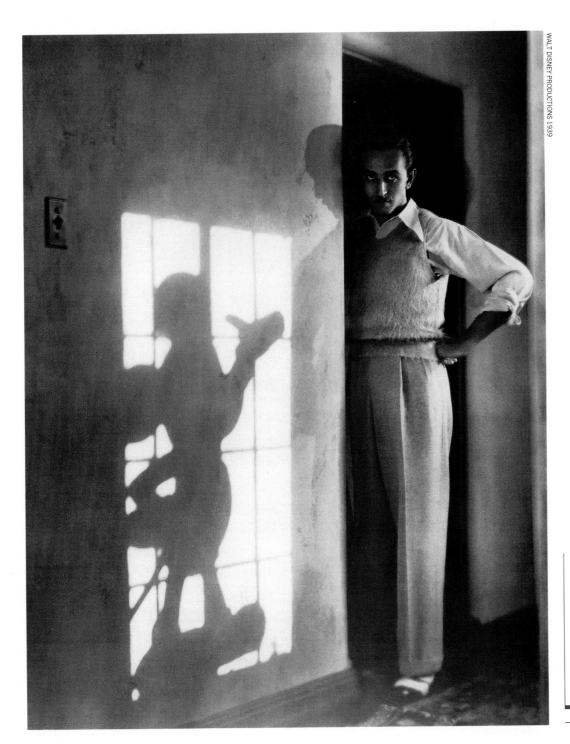

WALT DISNEY PRODUCTIONS 1939

JOHN BRYSON 1961

"I love Mickey
Mouse more than
any woman I've
ever known."

—WALT DISNEY

"Zest is the secret of all beauty."

— CHRISTIAN DIOR

GREAT BEAUTIES

▶ JOHN BARRYMORE 1882–1942

"[He] was Icarus
who flew so close to the sun that the wax on his wings melted **and he plunged** back to earth."

—BROOKS ATKINSON

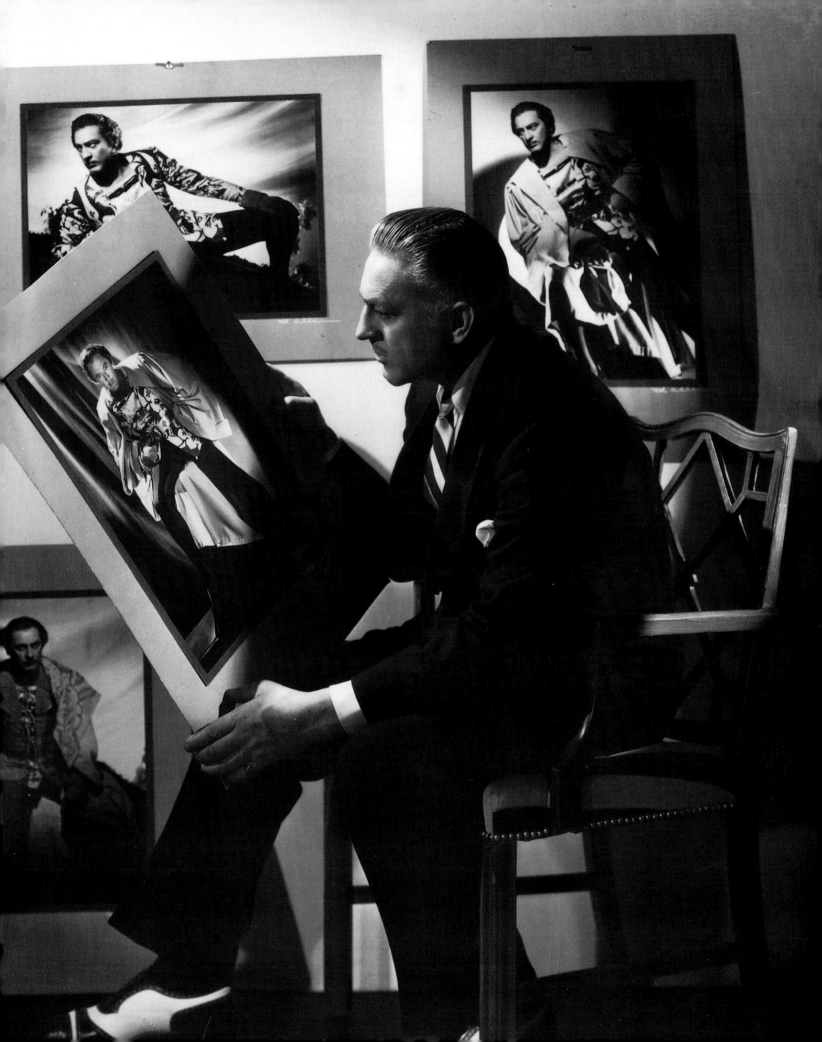

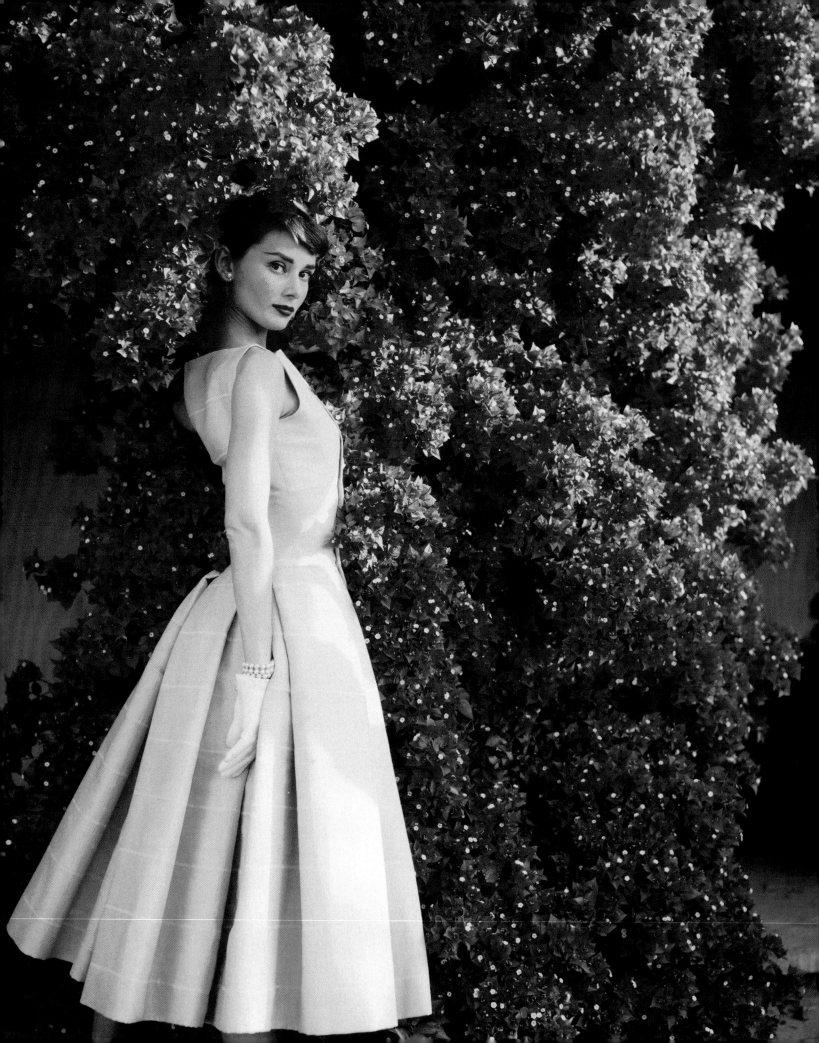

◀ AUDREY HEPBURN **1929–1993**

"This girl single-handedly could make bosoms a thing of the past!"

—BILLY WILDER

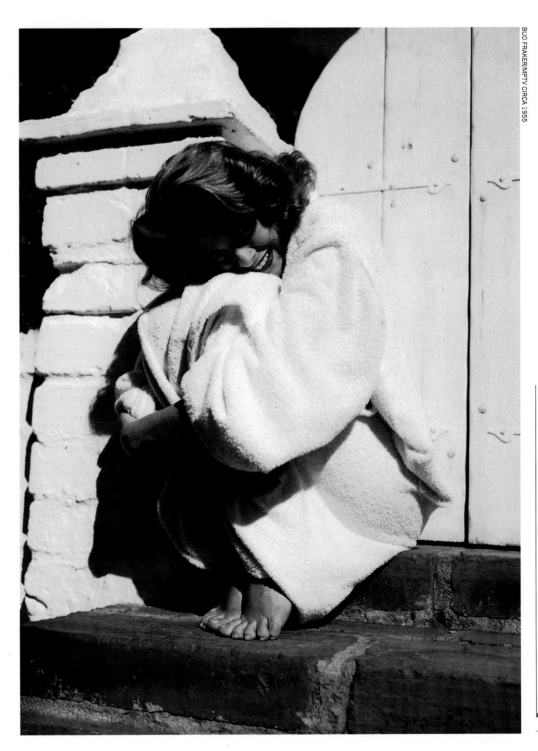

BUD FRAKER/MPTV CIRCA 1955

NORMAN PARKINSON/HAMILTON PHOTOGRAPHERS LTD. 1955

◀ **GRACE KELLY 1929–1982**

"Everything about Grace was appealing. I was married, but I wasn't *dead*. She had those big warm eyes and, well, if you had ever played a love scene with her, you'd know she wasn't cold."

—JIMMY STEWART

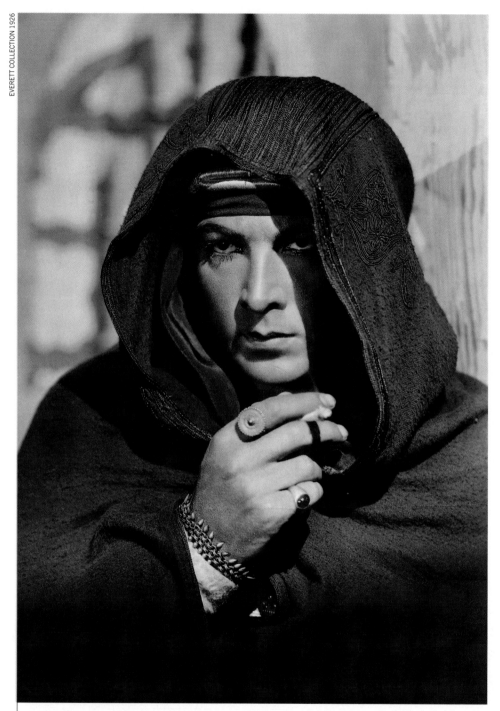

▲ **RUDOLPH VALENTINO** 1895–1926

"For *lover*, the thesaurus gives us Lothario,
Romeo, Casanova, Don Juan; most people,
I discover, give you *Valentino*."

—ADELA ROGERS ST. JOHNS

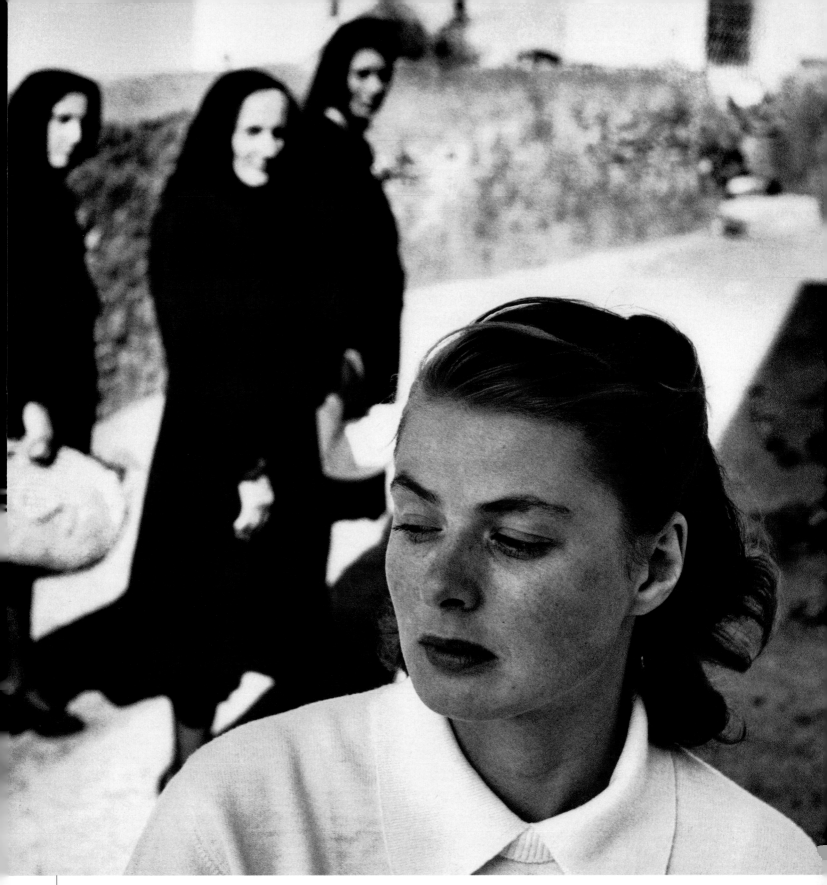

▲ INGRID BERGMAN 1915–1982

"She is much too normal to be a movie star."

—SALVADOR DALÍ

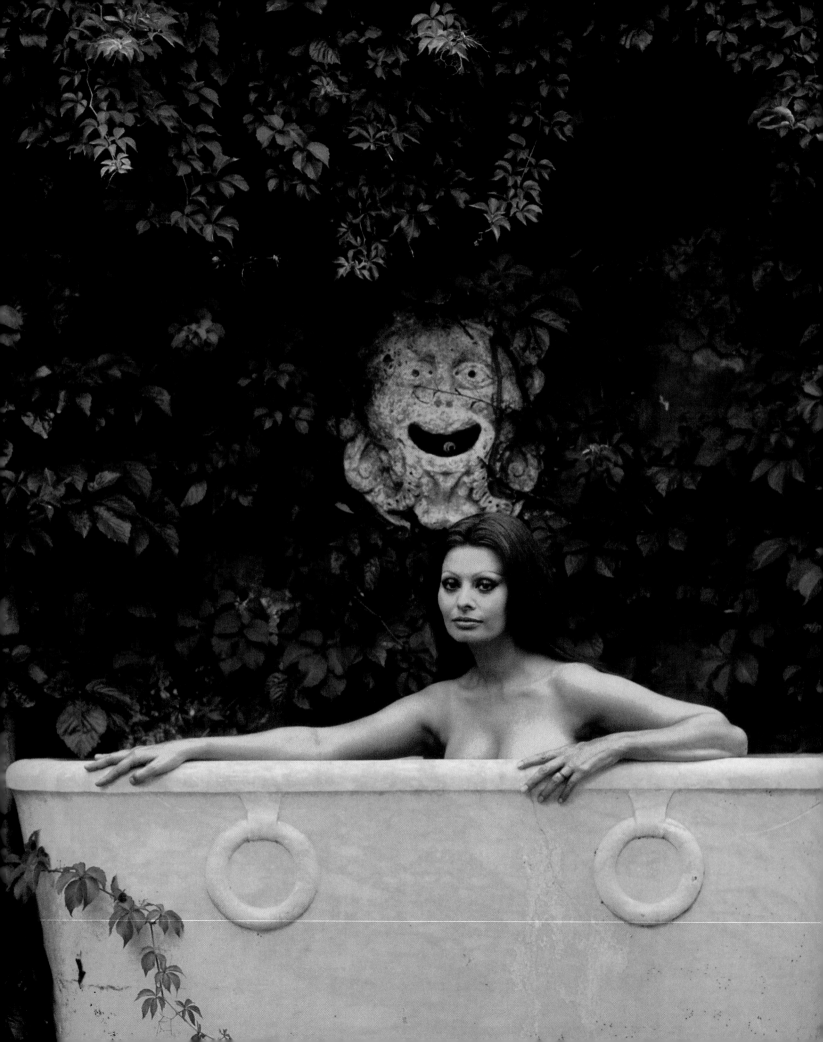

"She has sung duets with Noël Coward, dined with Queen Elizabeth and shooed President Tito of Yugoslavia out of her kitchen for sticking his finger in her spaghetti sauce . . . She has beaten Taylor, Burton and another friend, Peter O'Toole, at both Scrabble and poker."

—REX REED

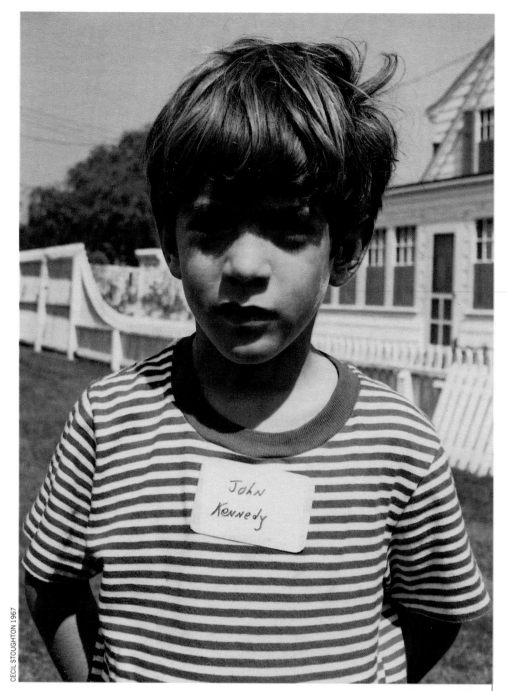

▲ JOHN F. KENNEDY JR. 1960–

"We Americans want to believe—
we want John-John to be happy."

—OPRAH WINFREY

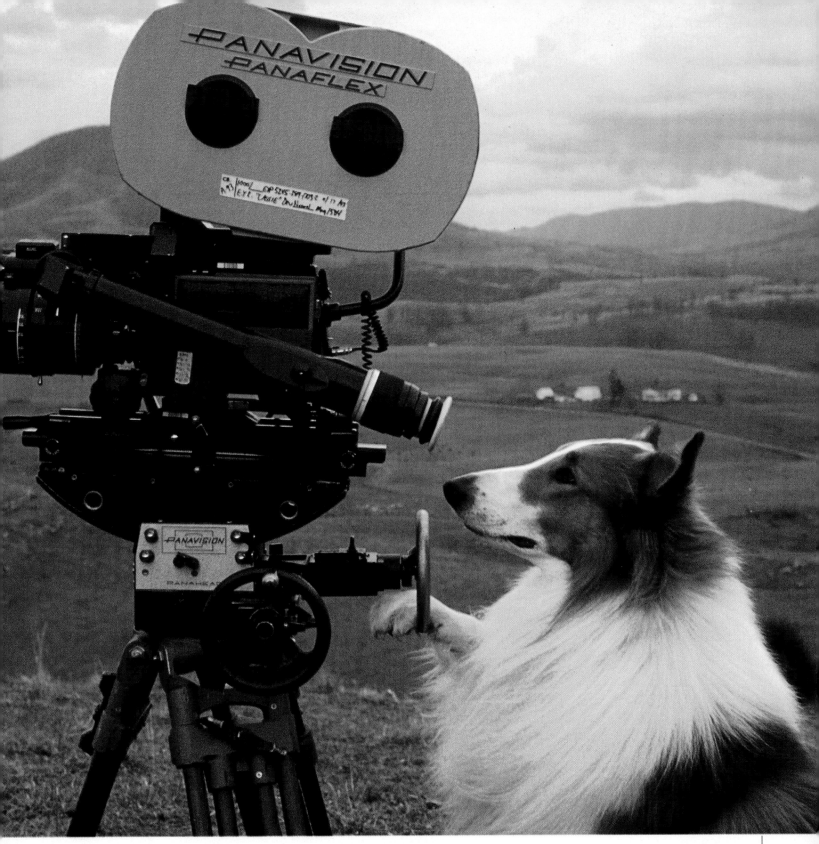

▲ LASSIE 1940–

"They had to find reasons for us to be morons,
so the dog could outsmart us."

—CLORIS LEACHMAN

"It is an absolute perfection . . . to get the very most out of one's individuality."

—MICHEL DE MONTAIGNE

MICHAEL JACKSON'S *THRILLER* JACKET

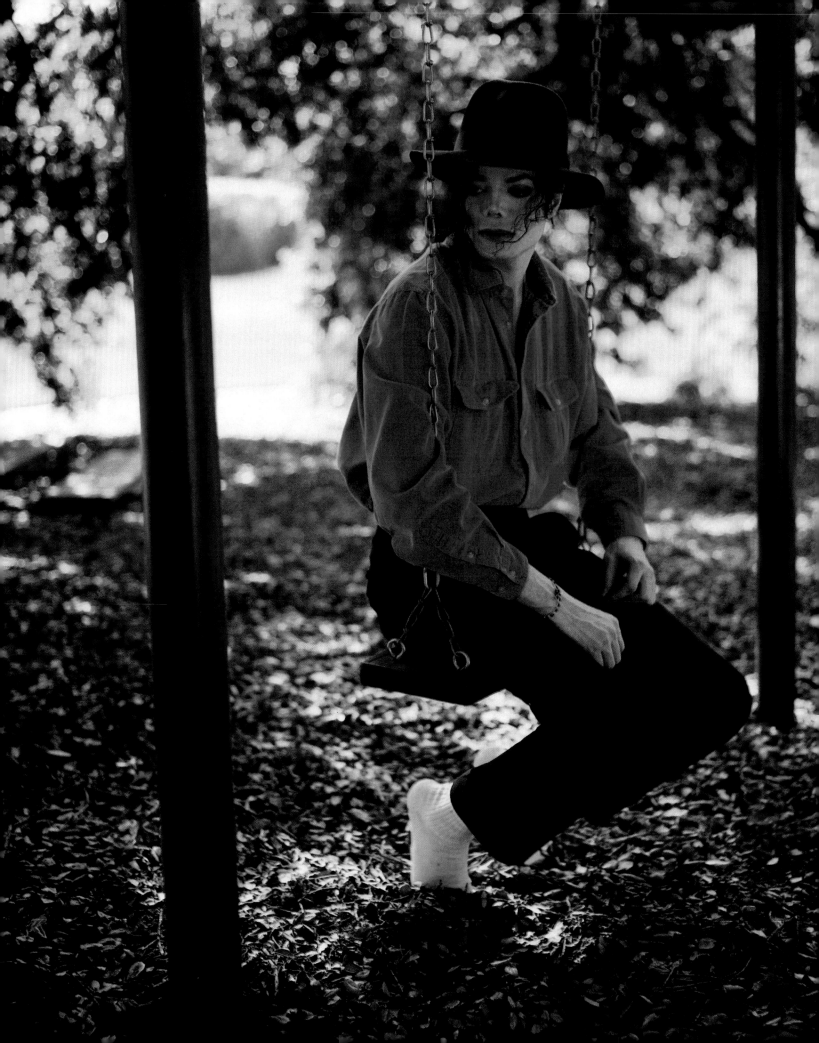

◀ **MICHAEL JACKSON 1958–**

"Introverted, shy and nonassertive. He wasn't at all sure that he could make a name for himself on his own. Neither was I."

—QUINCY JONES

139

"America never liked Josephine Baker . . . above all, they resented that she'd left America. What, she was supposed to stay here and become a maid?"

—DOROTHY DANDRIDGE

TED RUSSELL/SYGMA 1961

▲ J.D. SALINGER **1919–**

"Salinger of course speaks for the cleanest, politest, best-dressed, best-fed and best-read among the disaffected (and who is not disaffected?) young."

—LESLIE FIEDLER

140

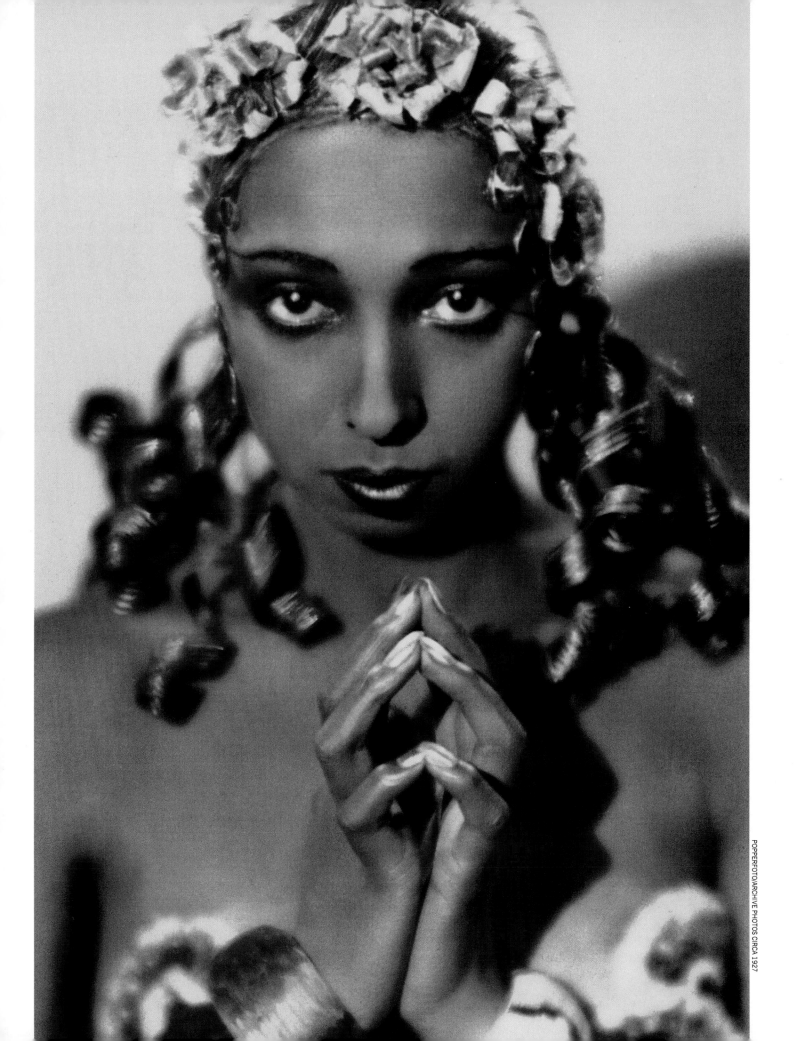

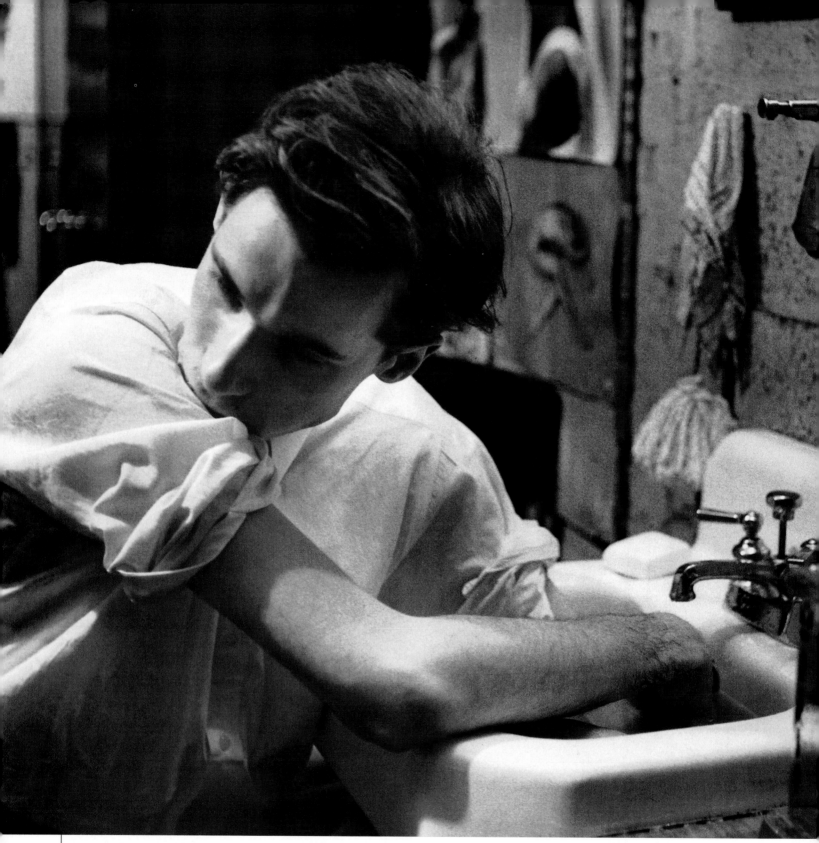

▲ GLENN GOULD 1932–1982

"This guy is such a genius.
And even if he's wrong, it's going to be gorgeous."

—LEONARD BERNSTEIN

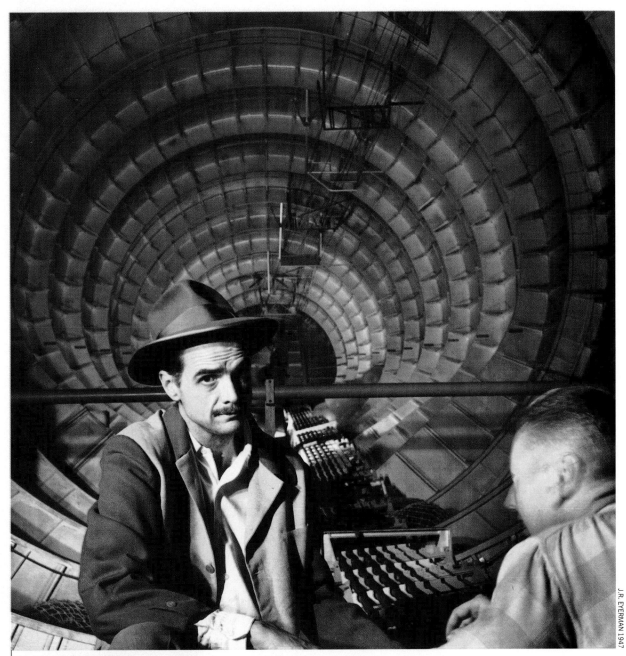

GORDON PARKS 1956

J.R. EVERMAN 1947

▲ **HOWARD HUGHES 1905–1976**

"Howard Hughes remains not merely antisocial
but grandly, brilliantly, surpassingly asocial.
He is the last private man, the dream we no longer admit."

—JOAN DIDION

► TIMOTHY LEARY **1920–1996**

"To all those who look to Dr. Leary for inspiration or even leadership, we want to say that your god is dead because his mind has been blown by acid."

—ELDRIDGE CLEAVER

144

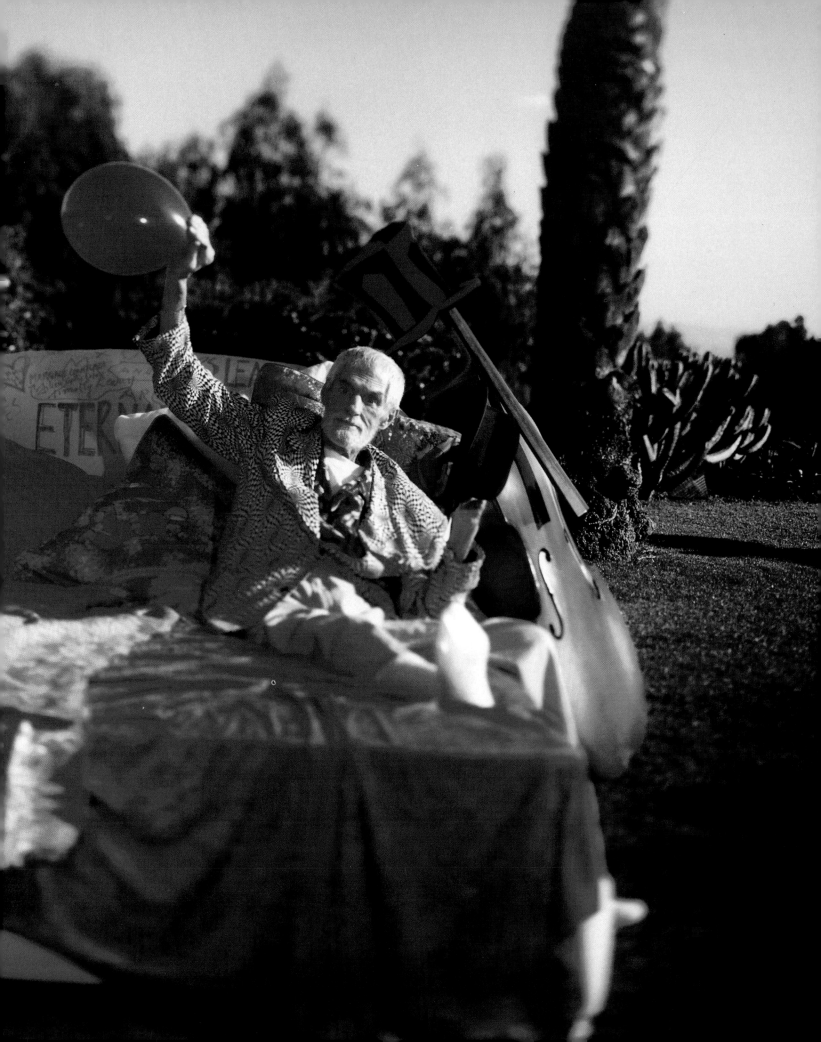

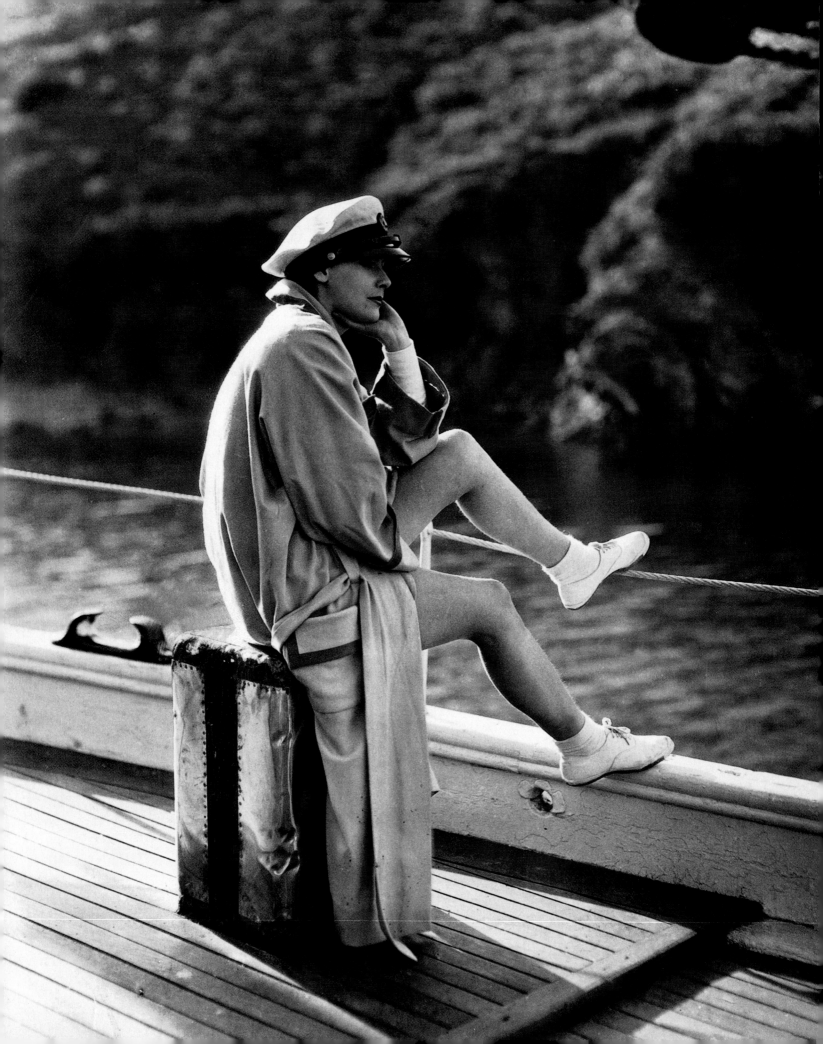

"What, when drunk, one sees in other women, one sees in Garbo sober."

—KENNETH TYNAN

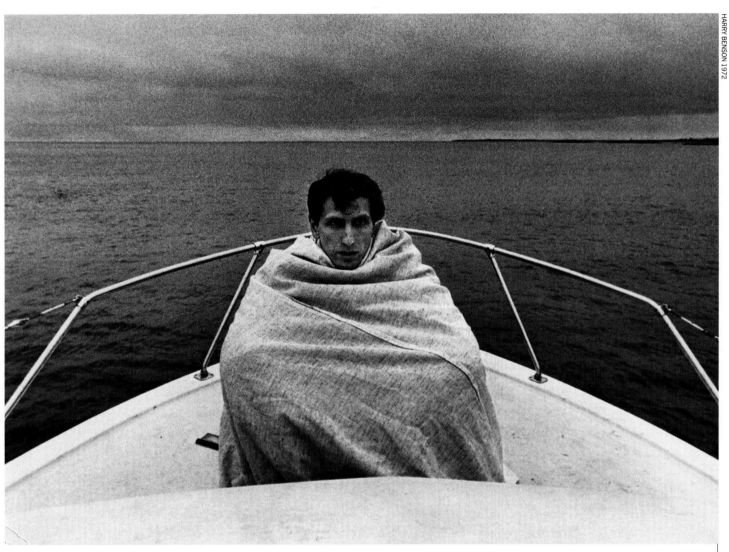

▲ **BOBBY FISCHER 1943–**

"Caught between reality and mentality . . .
He tried to convince himself he could prevent
any mistake and never lose. The horror!"

—GARRY KASPAROV

"Love
is the whole
and more than all."
—e.e. cummings

COUPLES

BARBIE'S CONVERTIBLE

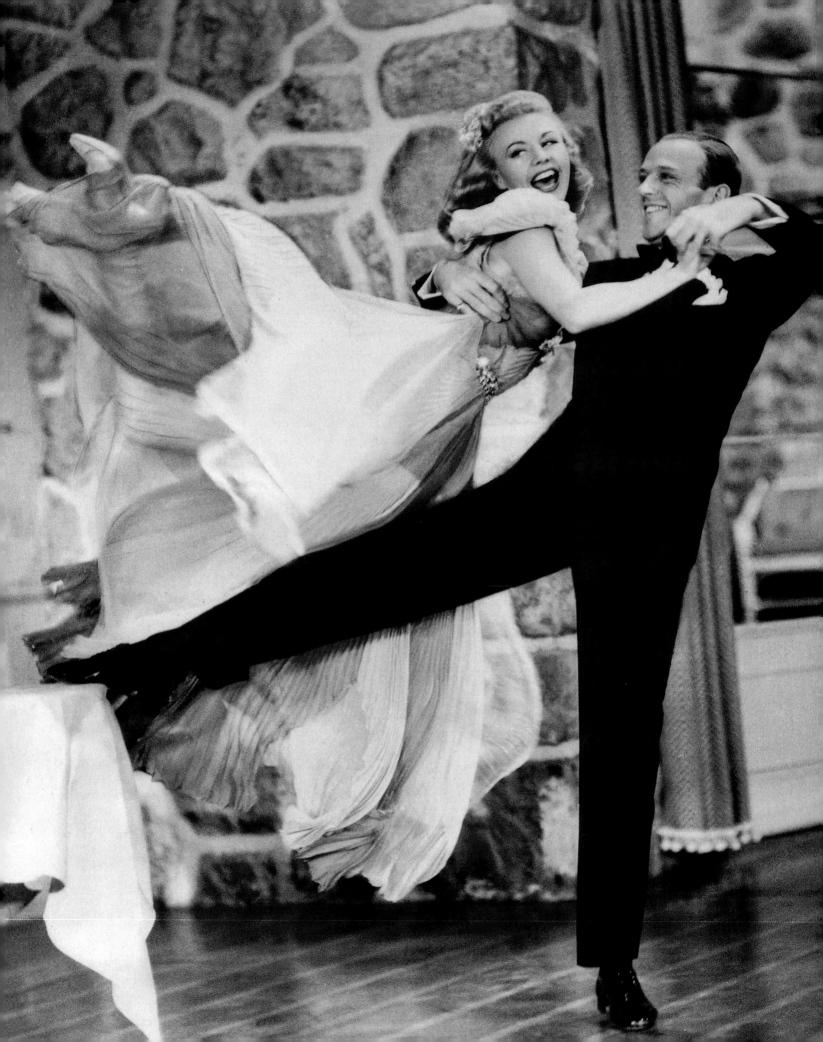

◀ FRED ASTAIRE **1899–1987** GINGER ROGERS **1911–1995**

"I am fond of Ginger,

but I absolutely do not want to be teamed with her or anyone else."

—FRED ASTAIRE

151

"The first time I saw George Burns onstage, I could see that he had what it takes to become a big star: Gracie Allen."

—BOB HOPE

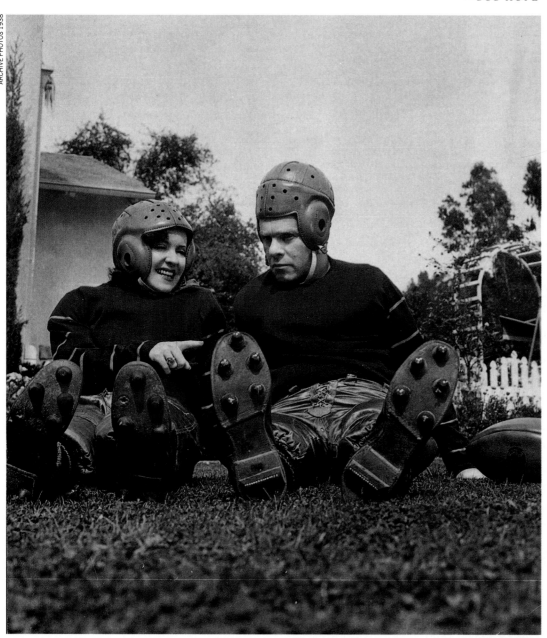

ARCHIVE PHOTOS 1938

ELIOT ELISOFON 1951

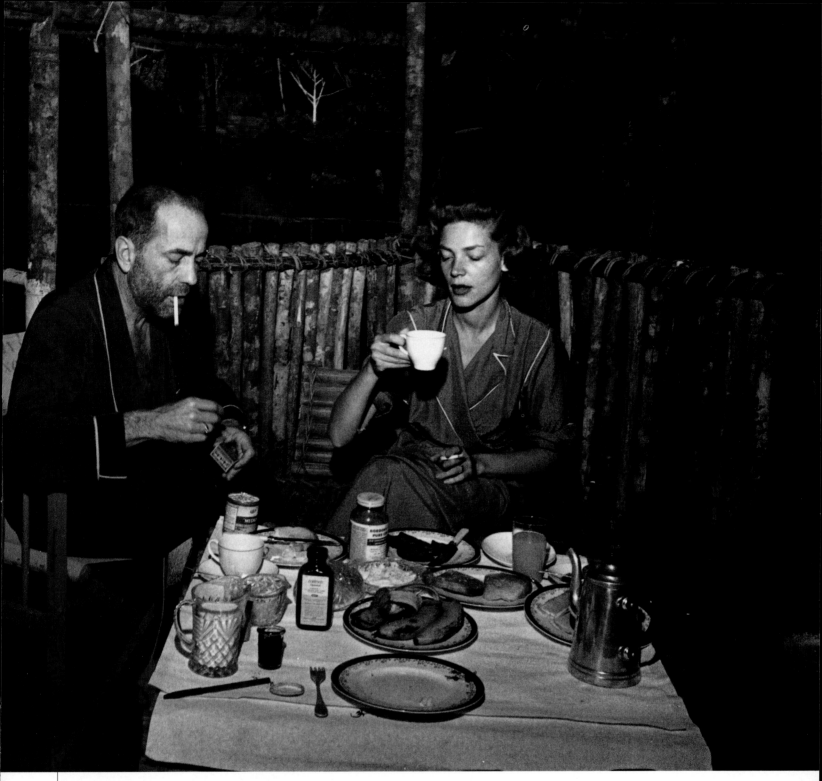

▲ HUMPHREY BOGART 1899–1957 LAUREN BACALL 1924–

"She and Bogie seemed to have the most enormous opinion of each other's charms, and when they fought, it was with the utter confidence of two cats locked deliciously in the same cage."

—KATHARINE HEPBURN

▶ SIMONE DE BEAUVOIR 1908–1986
JEAN-PAUL SARTRE 1905–1980

"Between us,
it was a
question of an
essential
love."

—JEAN-PAUL SARTRE

"It is beautiful that
our lives
coincided
for so long."

—SIMONE DE BEAUVOIR

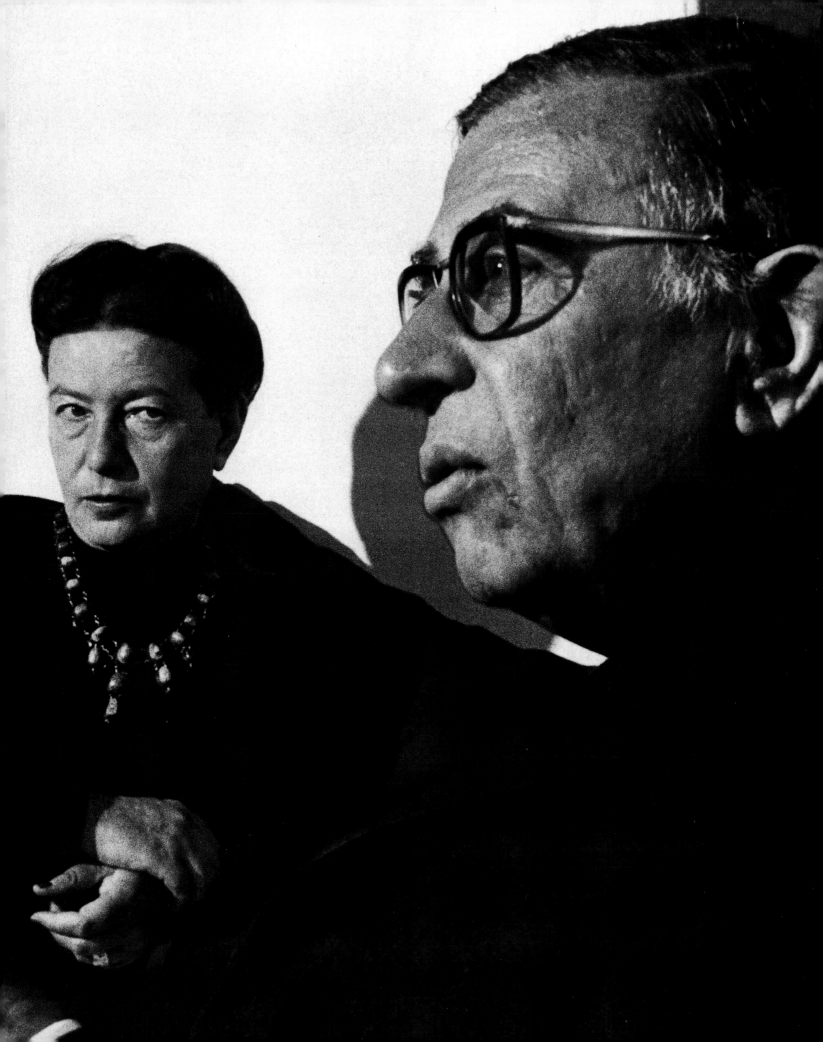

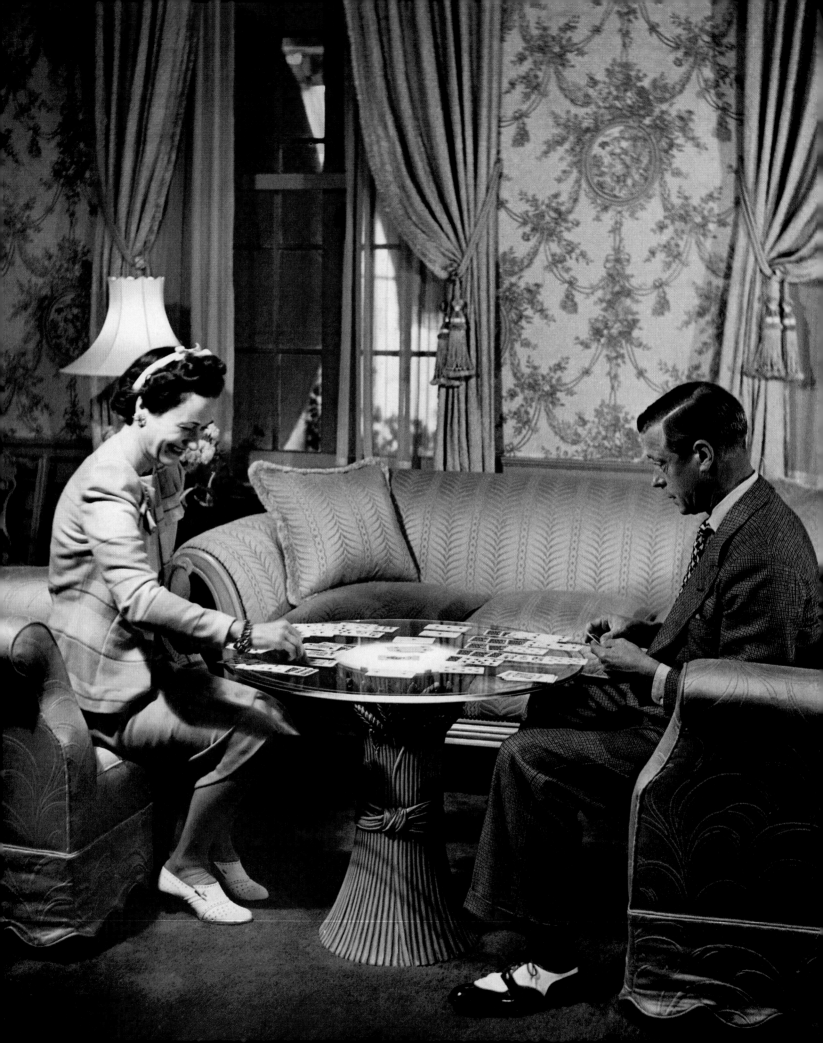

"He has not a single friend who is a gentleman. He does not see any decent society. And he is forty-one."—KING GEORGE V

"Wallis, you're the only woman who's ever been interested in my job."—THE DUKE OF WINDSOR

▲ BARBIE **1959–** KEN **1961–**

"Frankly, I'm a bit concerned about her constant career changes. This week it's Dentist Barbie, last week it was Pet Doctor Barbie, the week before, Teacher Barbie. I think you see my dilemma here." —KEN

"My greatest concern regarding Ken can be summed up in a single word: commitment. I mean, we've been dating for thirty-five years now and nothing ever seems to change." —BARBIE

"It seems to me you lived
your life like a
candle
in the
wind."

—ELTON JOHN

In de zomer van 1941 werd Oma Hollän-
der erg ziek (zij was toen al bij ons) zij
moest geopereerd worden. En haar wer-
verjaardag beleven wij toen wel.

In Januari 1940 oak niet, want toen was
de oorlog net naardig in Nederland.

Deze winter 1941–1942 is Oma gestorven.
En niemand weet hoeveel ik aan haar
denk en nog van haar houdt.

Deze verjaardig 1942 is dan ook ge-
weerd en alleen in halve en ook is
lichtij stond er naast.

Vrijdag 19 Juni 1942.

Gisteschend was ik thuis, ik heb heel
erg lang geslapen. toen kwam Hanne-
li en hebben we nog wat gekletst.

Jacque is nu opeens erg met Ilse
ingenomen en doet erg kinderachtig
en flauw tegen mij. Ilse valt mij hoe
langer hoe meer tegen. Anne

Dit is Juni 1939.
Dat is de enige foto van
Oma Hollander, aan
haar denk ik nog
zo vaak en ik wou
dat ik nog maar
de kiniëlijke vrede
bewaarde.

Dit is in
't 1940,
nog een
Margot en
ik. Ik wou

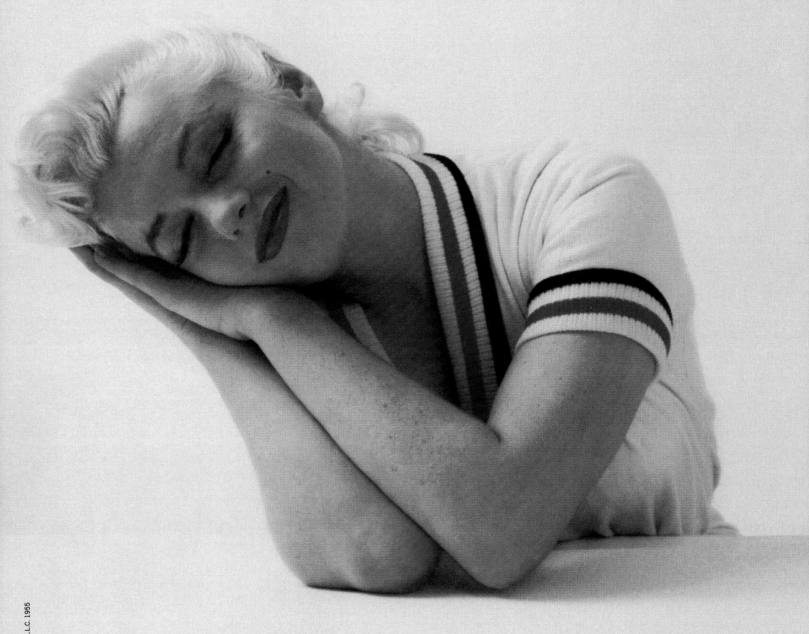

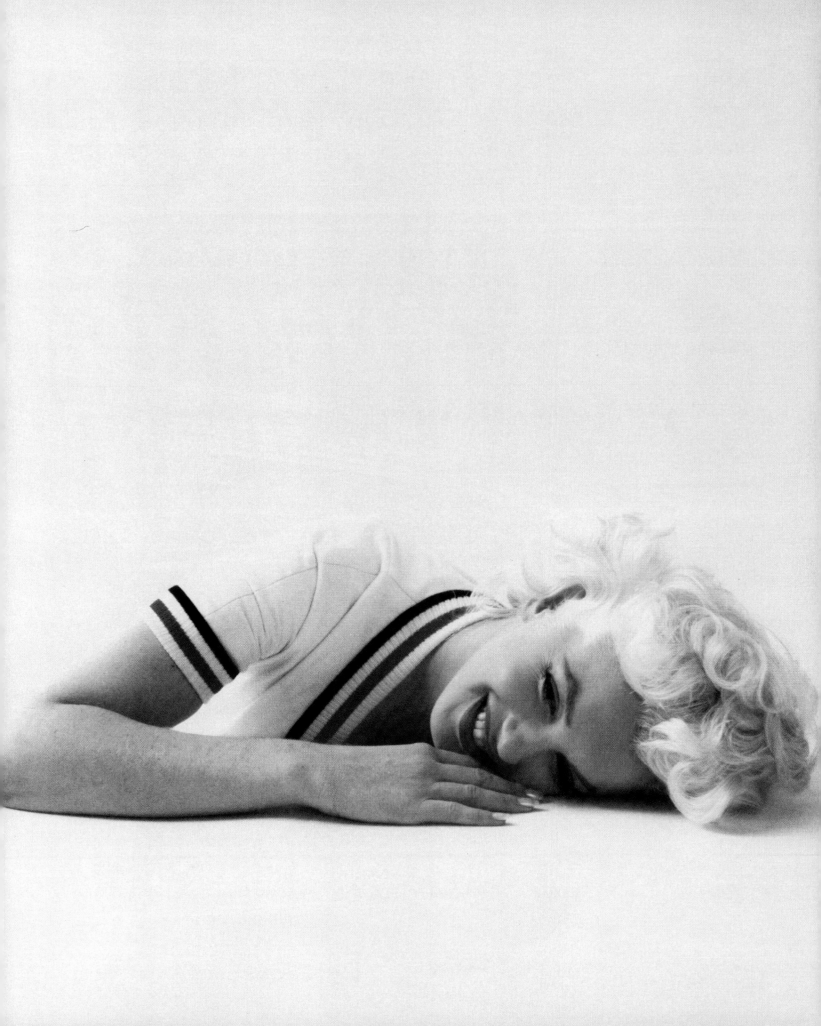

► JANIS JOPLIN 1943–1970

DAVID GAHR 1969

"That girl has problems...
Bein' heard ain't one of 'em."

—ETHEL MERMAN

◄ MARILYN MONROE
1926–1962

"When you look at Marilyn on the screen, you don't want anything to happen to her. You really care that she should be all right."

—NATALIE WOOD

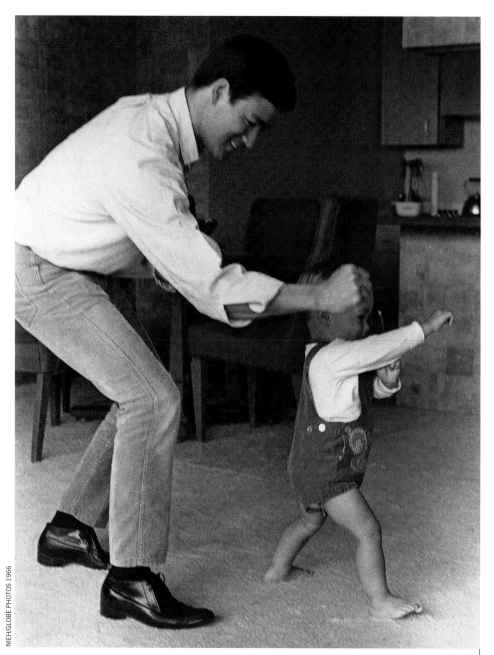

NIEH/GLOBE PHOTOS 1966

▲ BRUCE LEE 1940–1973

"My dad said time was the most valuable thing a person had."

—BRANDON LEE

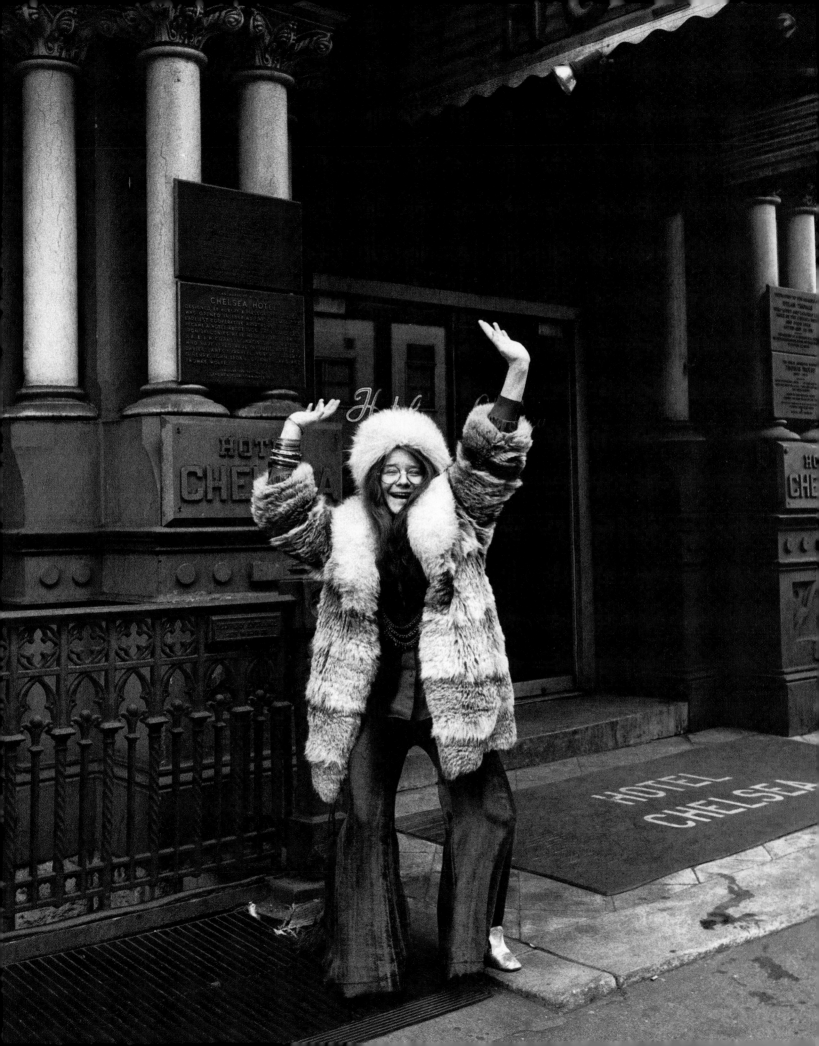

"He was a real nice guy, quiet but intense, and was nothing like people thought he was. He was just the opposite of the wild and crazy image he presented on the stage . . . He would pick up things from whoever he was around, and he picked up things quick . . . Then he started incorporating things I told him into his albums. It was great. He influenced me, and I influenced him, and that's the way great music is always made."

—MILES DAVIS

LINDA McCARTNEY 1968

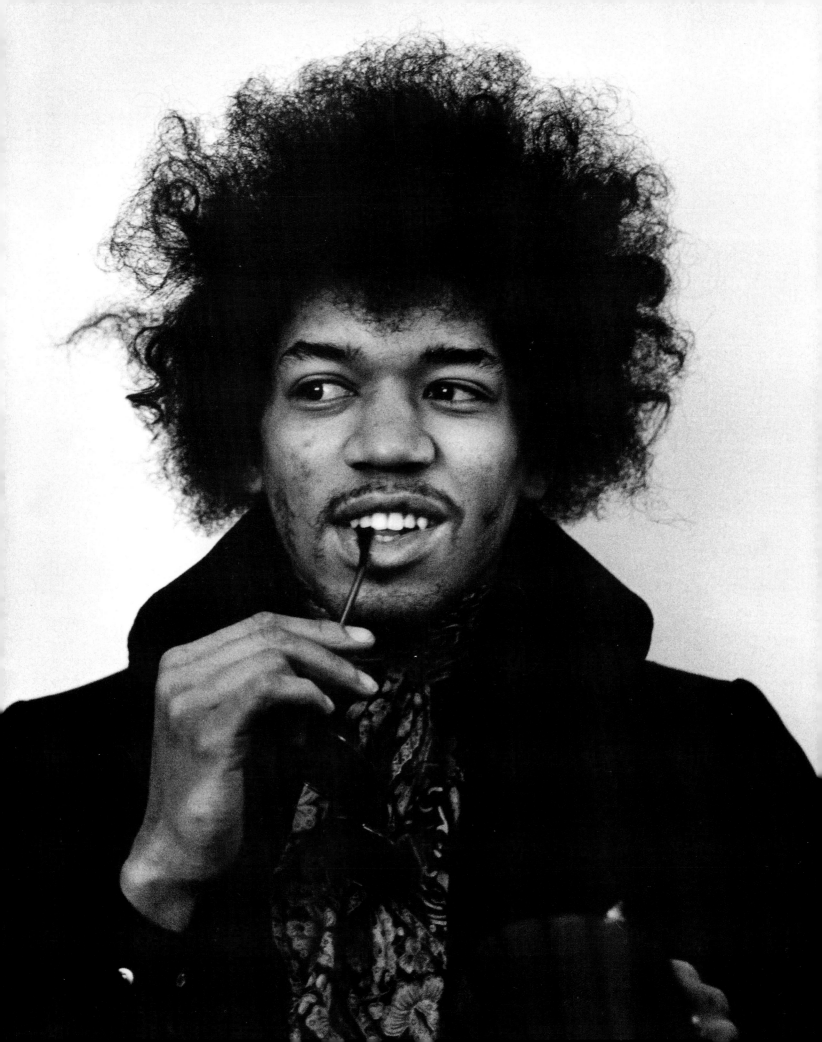

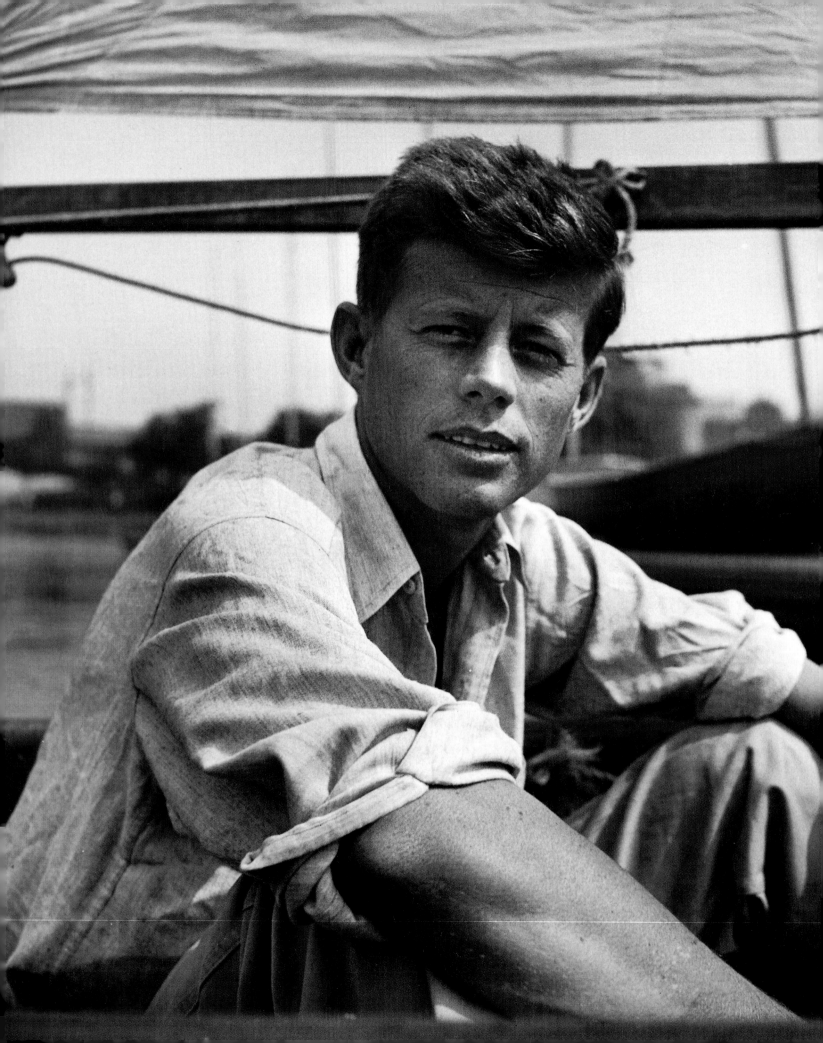

◄ **JOHN F. KENNEDY 1917–1963**

"I should have guessed that it would be too much to ask to grow old with him and see our children grow up . . . So now he is a legend when he would have preferred to be a man."

—JACQUELINE KENNEDY ONASSIS

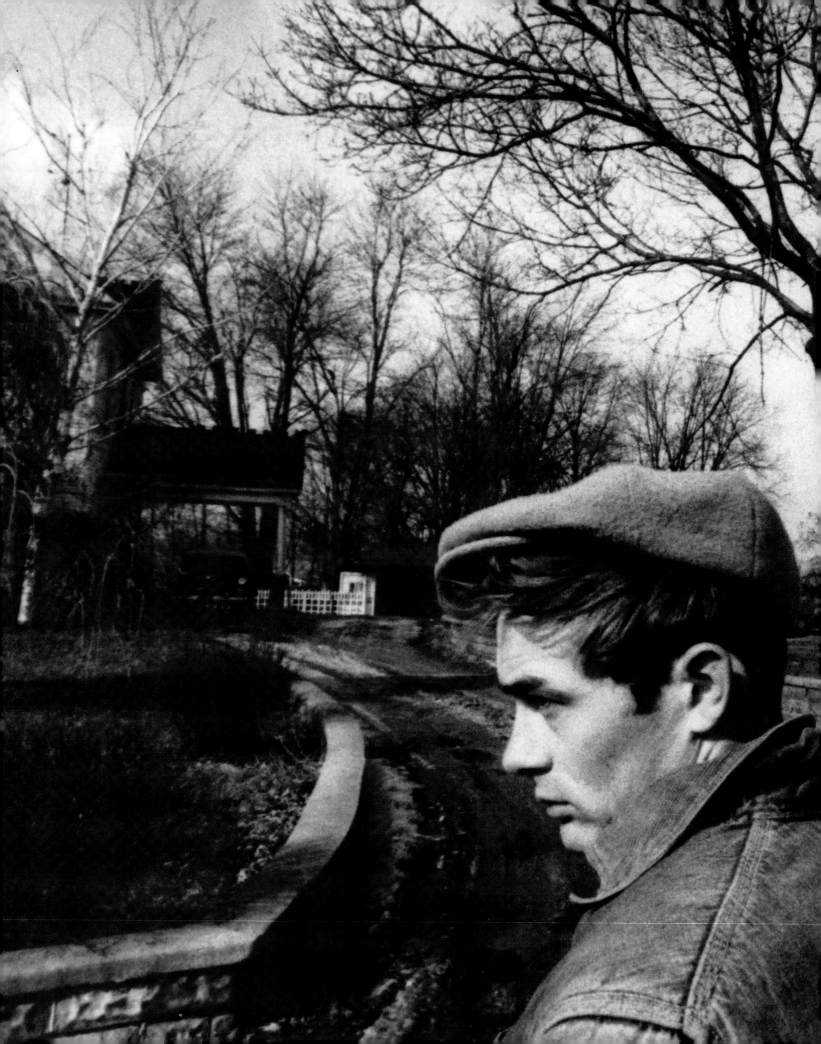

► JEAN HARLOW 1911–1937

"Her technique was the gangster's technique— she toted a breast like a man totes a gun."

—GRAHAM GREENE

◄ JAMES DEAN
1931–1955

"I know why girls, at least the young 'uns, go for us. We're sullen, we're brooding, we're something of a menace. I don't understand it exactly . . . but I know you can't be sexy if you smile. You can't be a rebel if you grin."

—ELVIS PRESLEY

▲ PATSY CLINE 1932–1963

"You're the most innocent, the most nervous, most truthful and honest performer I have ever seen. There is surely stardust on you."

—ARTHUR GODFREY

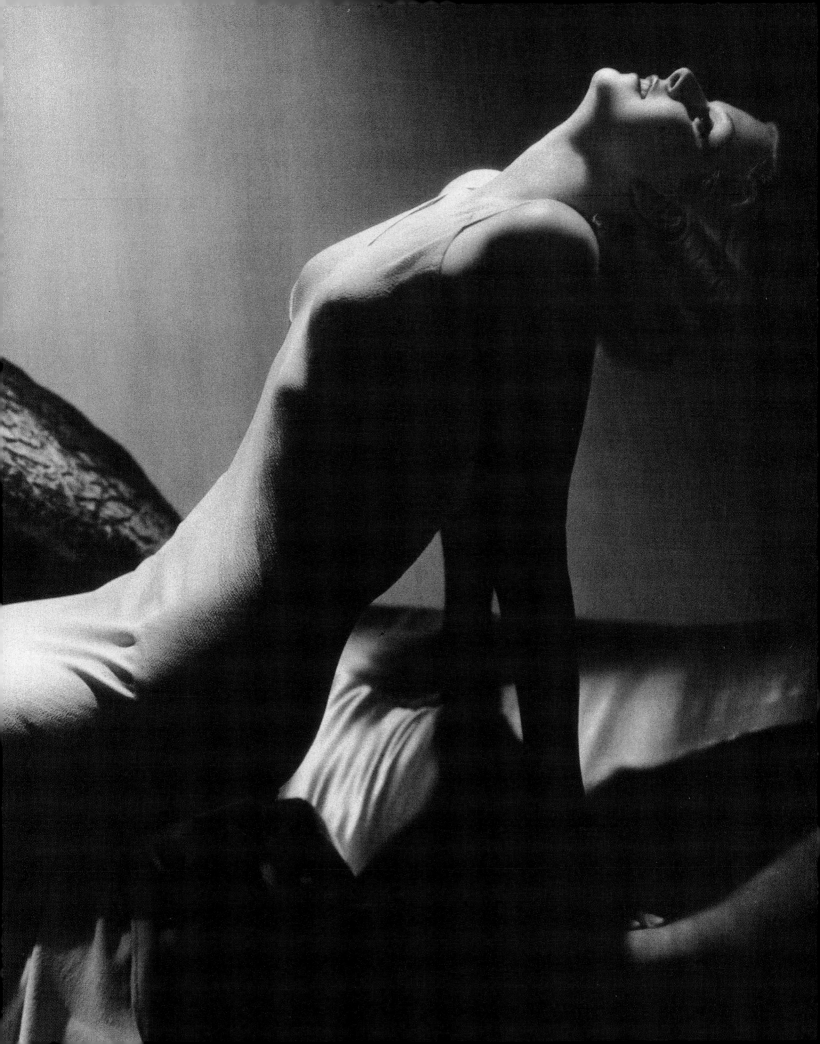

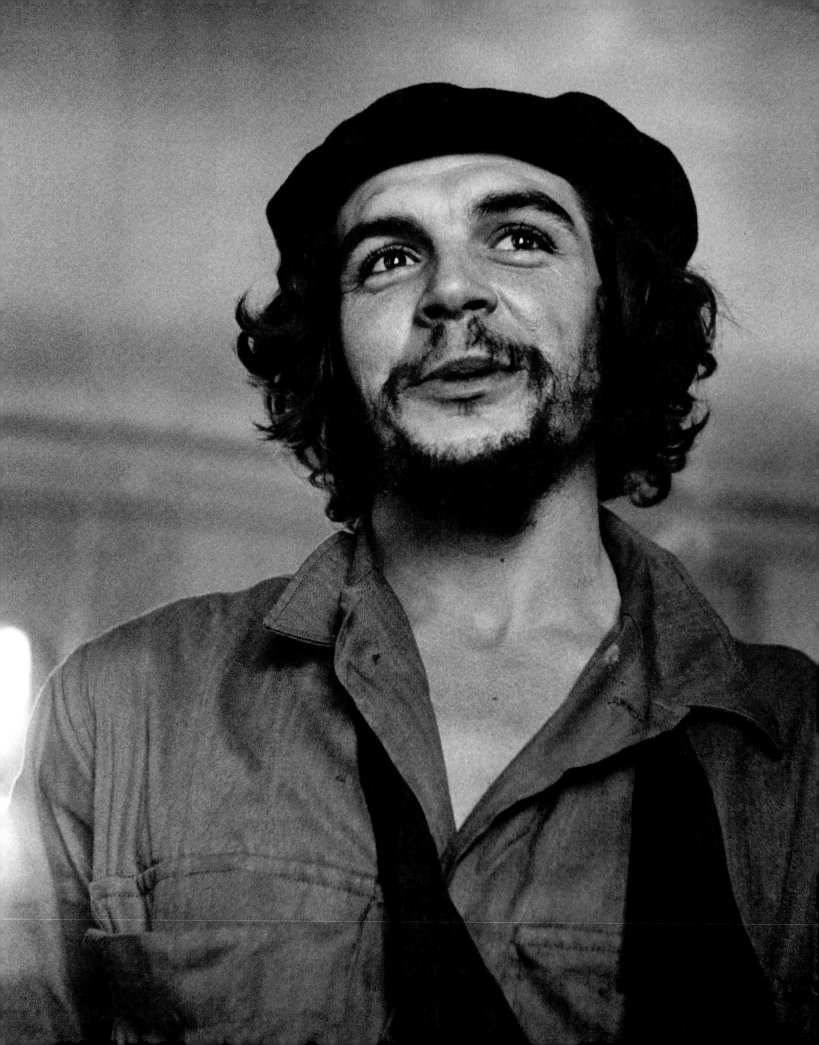

"All the time we knew him, he was always characterized by an extraordinary impetuousness, by the absolute scorn for danger... We were always worried about the possibility that his temperament, this behavior of his in moments of danger, could lead him to death in any battle."

—FIDEL CASTRO

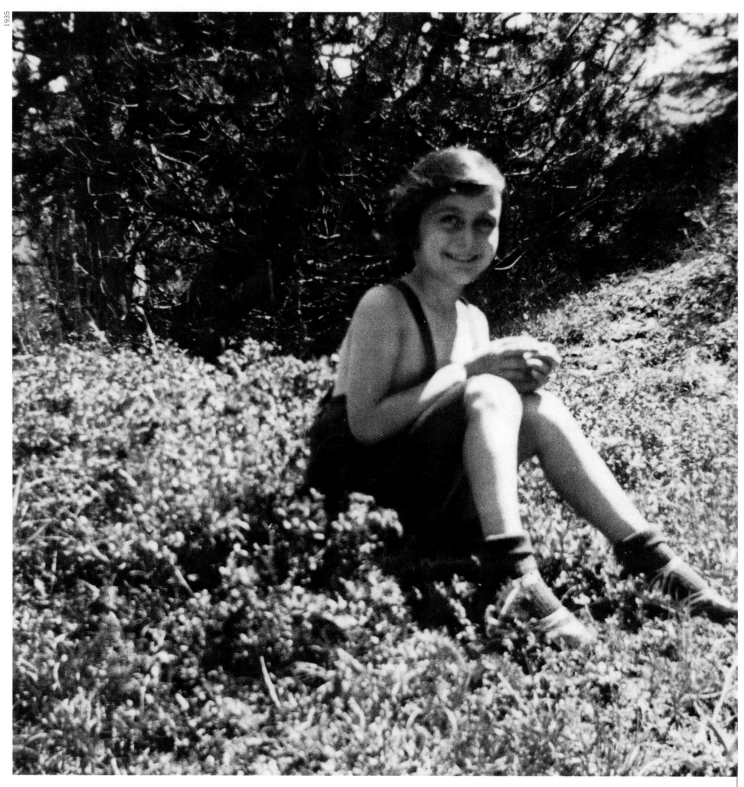

▲ ANNE FRANK **1929–1945**

"Hoping. Dreaming. Believing…
And finally, listening to Evil itself hammering on the door."

—LIV ULLMANN

Our photographic subjects are listed in bold type (**00**); those who are quoted about the subjects, and those who are quoted or noted at the opening of each chapter, are listed in roman type (00).

Page 46

Page 152

Page 128

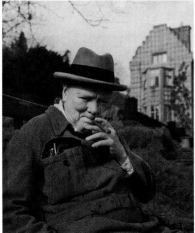

Page 62

Page 157

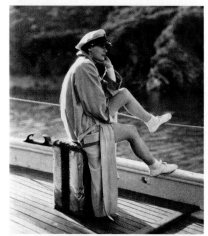

Page 146

Page 44

Page 54